the Artist's sketchbook

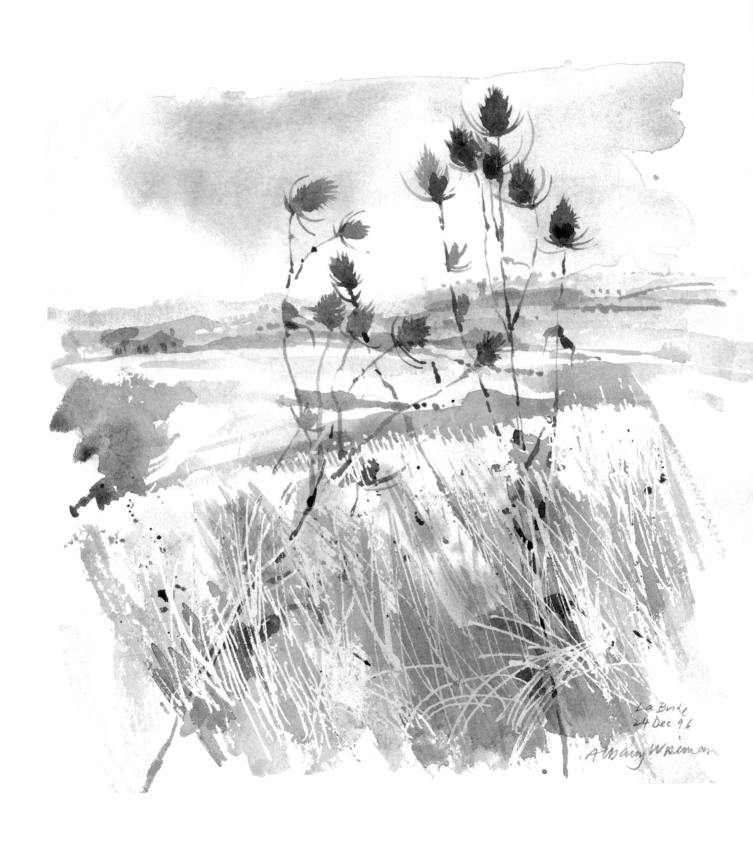

La Bride
24 Dec 96

A Mary Wiseman

the Artist's Sketchbook

ALBANY WISEMAN
WITH PATRICIA MONAHAN

David & Charles

FOR JUNE

The authors and publishers are extremely grateful
to His Royal Highness The Prince of Wales for
kindly providing the Foreword for this book.
And for continuing to encourage all to learn to
draw and essentially observe what is around them.

A DAVID & CHARLES BOOK

First published in the UK in 2000

A catalogue record for this book is available from the British Library.

ISBN 0 7153 0965 X

Designed by Paul Cooper Design
and printed in Hong Kong by Dai Nippon
for David & Charles
Brunel House Newton Abbot Devon

CONTENTS

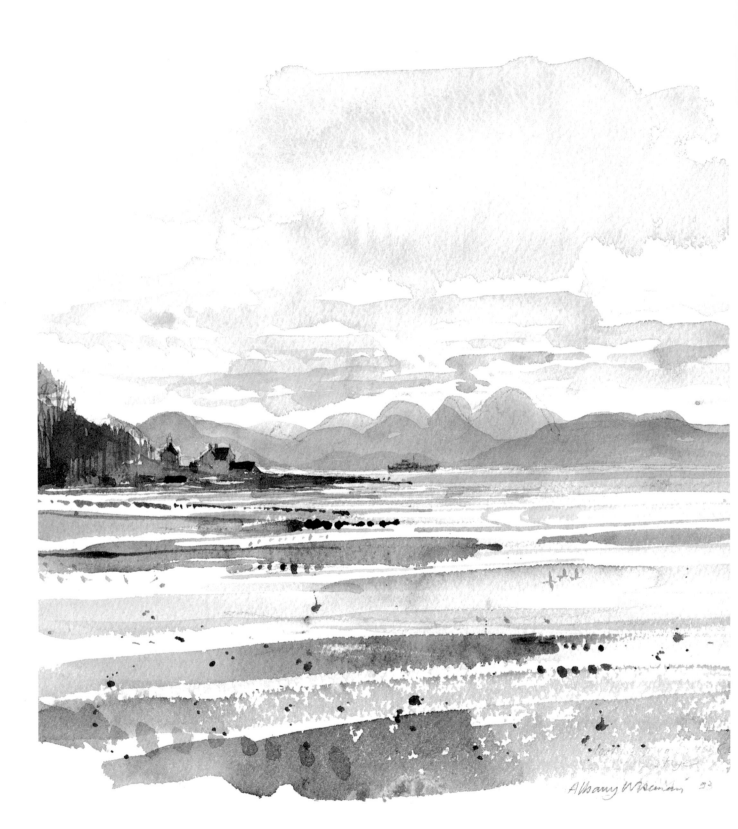

APPLECROSS, WESTERN ISLES OF SCOTLAND

FOREWORD
by HRH The Prince of Wales

Wherever I am I always try to snatch a few peaceful moments to jot down my impressions of the landscapes and places that I visit. Consequently I know only too well the importance of the sketchbook and of the frustrating difficulties of making quick and fluent drawings.

As technology advances at an alarming pace, the place of drawing remains as valid as ever in the creation of art and architecture. This is very much reflected at my Foundation for The Built Environment and Urban Regeneration where great emphasis is placed on developing the disciplines of drawing in the student curriculum.

I am sure that this book will give much pleasure and support to all artists, and to all those beginners embarking on this exciting journey.

HRH The Prince of Wales
St James's Palace

CHAPTER 1
INTRODUCTION

Why does a fine sketch please us more than a fine picture? It is because there is more life in it ... Why can a young student, incapable of doing even a mediocre picture, do a marvellous sketch? It is because the sketch is the product of enthusiasm and inspiration, while the picture is the product of labour, patience, lengthy study and consummate experience in art.

DENIS DIDEROT, 1767

The sketchbook is the visual artist's most valuable tool and resource. From architects to dress designers, film designers to sculptors, every artist needs to get ideas and images on to paper quickly, efficiently and effectively.

The sketchbook fulfils many functions. Its most notable characteristic is its privacy. The work in your sketchbook is not on display, so you can afford to experiment, take chances and make mistakes in a way that you would not in 'finished' drawings or paintings.

Like a musician, an artist needs to practise every day and a sketchbook is an ideal place to work on your observational and drawing skills. In time you will learn to select and simplify so that you can encapsulate an attitude, a pose or a movement in a few lines. Sketching regularly also improves visual memory and manual dexterity, enabling you to make accurate and rapid records of the subjects that interest you. Leonardo da Vinci (1452–1519) filled notebooks with many figure drawings, nature studies and numerous ideas for inventions.

The sketchbook is also a visual diary of places and people, family life, holidays and important events. Before photography it was often the only record of journeys and places seen. In the eighteenth century educated European gentlemen went on the 'Grand Tour', travelling, often for years, to all the historically and artistically significant sites in Europe and beyond. Often they took their drawing master with them, not only to teach but to make records of all the things they saw. People even travelled in their own countries deliberately searching out sublime and picturesque landscapes to sketch and paint.

The artists of the Romantic period, between the mid-eighteenth and mid-nineteenth centuries all kept wonderful sketchbooks. Francisco de Goya (1746–1828), Jacques Louis David (1748–1825), William Blake (1757–1827), J. M. W. Turner (1775–1851), John Constable (1776–1837), Théodore Géricault (1791–1824) and Eugène Delacroix (1798–1863) all recorded and studied both the figure and landscape.

A well-kept sketchbook will trigger memories and provide enjoyment in years to come. I have kept a sketchbook since I was in my teens and I now have over a hundred. I constantly refer to them, looking for images, inspiration and also reference material in order to solve particular problems.

I use my sketchbook to gather information for paintings, illustrations and prints, for work done to commission and for more personal work. For example, if I am illustrating a book and need a drawing of a particular architectural feature or a type of boat, I will go out with a sketchbook and drawing materials. It is a useful place in which to develop ideas, to play around with compositions, and to experiment with materials.

I hope this book provides some encouragement to keep and use sketchbooks, and to enjoy the pleasure of drawing and painting. It is never too early or late to start.

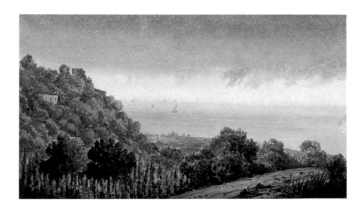

SORRENTO, AUGUST 1848
This meticulous and romantic watercolour comes from a large Victorian scrapbook I bought at an auction. It would be fascinating to know something about the anonymous painter – his or her background, and why they were in Sorrento.

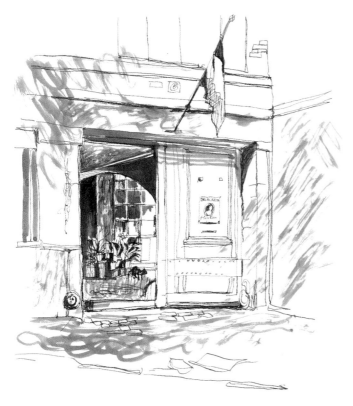

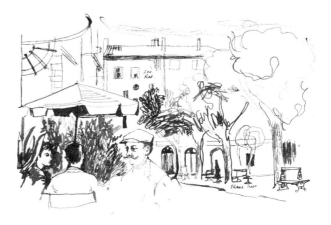

FRANCE (left and above)
The sketch on the left is of Delacroix's studio in Paris, while the one above is of Villefranche in Burgundy. Both sketches were made on a hitch-hiking trip through France with an art school colleague in 1950. Both are drawn in watersoluble ink and dip pen, with brush and ink for the areas of intense shadow.

AT EASE (below)
For this sketch of a soldier reading on his bed I used sepia ink and a dip pen, smudging here and there with my fingertip. The drawing is quite finished so I probably spent some time on it. This drawing and the study in Egypt were both from sketchbooks during my National Service in the 1950s.

EGYPT
This study was made using dip pen and ink on white cartridge paper. Sometimes you just have to use what is to hand.

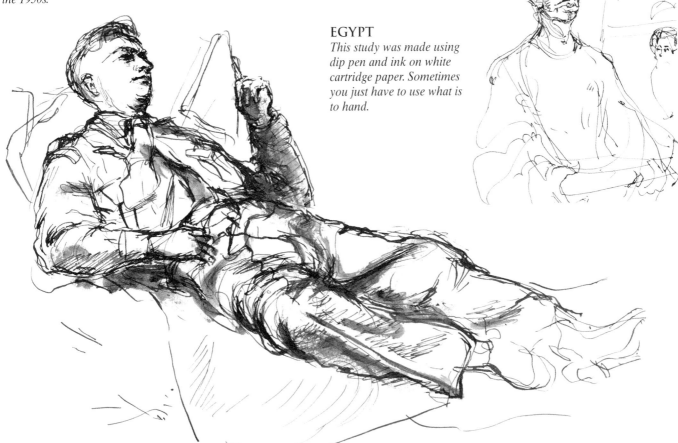

BUYING OR MAKING A SKETCHBOOK

When you go into an art supplies store you will be faced by a bewildering array of sketchbooks in all shapes and sizes, with different bindings and papers. Faced with this abundance how on earth do you make a choice? Start by considering which medium or media you are likely to use, for each requires a different surface. Papers for watercolour, for example, must be well sized and reasonably thick or they will cockle disappointingly. The surface of the paper varies, too – from smooth to quite rough – and the choice will be a matter of personal taste. Specific papers are available for use with pastel; they have a special surface texture or 'tooth' for holding the pigment. There are even special pads of paper designed for oil and acrylic paints.

Another consideration is the way in which you intend to use the sketchbook. If you want to keep a complete volume as a permanent record then a casebound sketchbook will be best. If, however, you intend to remove sheets – perhaps to frame them – then a spiral-bound or glued pad will be more useful.

Think about the size of the sketchbook. A pocket-sized sketchbook is portable and allows you to work discreetly without attracting attention. A large sketchbook, however, allows you to work more freely and to create multiple images.

You can even make your own sketchbook. The advantage is that you can include a variety of papers and make it very personal to you.

MAKING A SKETCHBOOK

1 *Start by deciding how big you want the sketchbook to be. Mark out a rectangle on thick card and allow sufficient room for the spine and a fold along the front edge. This sketchbook will measure 15 x 20cm (6 x 8in).*

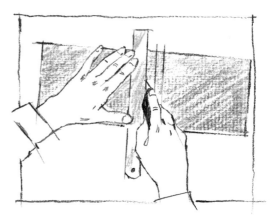

2 *Cut out the card rectangle, using a metal-edged ruler and a sharp craft knife. Score lightly along the lines of the spine, taking great care not to cut all the way through the card.*

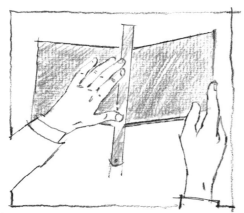

3 *Place a metal ruler along the scored line of the spine and carefully bend the card upwards. Repeat for the second spine line. The card may crack slightly, but do not worry: the cracks will be covered at the next step.*

4 *Place fabric-backed adhesive tape over the spine to cover up any cracks in the card and to provide reinforcement. Smooth out the adhesive tape so that there are no wrinkles in it.*

5 *Using a bradawl or other sharp pointed implement, make two holes along the fold of the spine, spacing them so that there is 8cm (3in) between the centre of one hole and the centre of the next – this is the width of a hole punch.*

6 *Cut a rectangle of decorative paper approximately 2.5cm (1in) bigger all round than the sketchbook, and carefully glue it to the front, butting it up to the edge of the fabric-backed adhesive tape. Smooth out any wrinkles.*

7 *Turn the sketchbook over and fold over the excess paper, gluing it to the inside of the sketchbook. (Cut across the corners of the excess paper first to give a neat mitred edge.) Repeat steps 6 and 7 on the back of the sketchbook.*

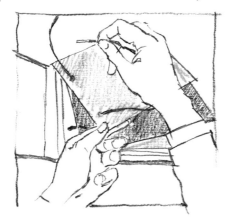

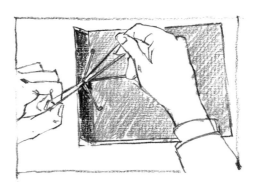

8 *Thread a shoelace through the holes in the back of the sketchbook. Cut paper for the sketchbook and use a punch to make holes in one edge, making sure that they align with the holes in the cover. Thread the paper on to the shoelace.*

 A band of elastic with a loop for the pencil will hold the sketchbook closed.

9 *Thread the shoelace through the front of the sketchbook. Pull taut, but not too tight, or you may tear the paper inside. Tie the shoelace in a neat bow to finish.*

Tips:
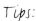 No one ever needs to see your sketchbook, so do not worry about making mistakes. In fact, you will find that your sketches turn out much better than you expect and you will be quite happy to let people see them.

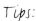 Get into the habit of carrying a small sketchbook and a pen or pencil with you. Set yourself the target of making at least one sketch a day.

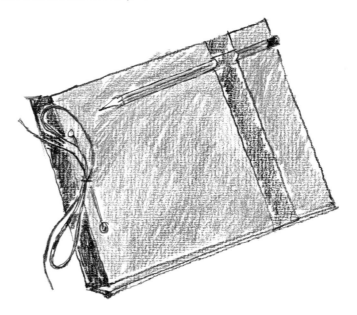

MATERIALS FOR SKETCHING

The choice of drawing and painting media available to the artist today is breathtaking and confusing – as you will find on a visit to any art supplies store – and manufacturers are constantly coming up with clever new products. When deciding what you are going to use in your sketchbook, personal taste comes top of the list. If you like a medium and feel comfortable with it you are more likely to use it. Sketching tools should be simple and portable, and you will probably want to add colour to your sketches on occasions.

Graphite pencils are simple, cheap, portable, and remarkably flexible and expressive. The degree of hardness is designated by a number and a letter, with HB being medium in the range. The soft grades range from B to 8B, which is the softest. Hard pencils are graded from H to about 10H, the hardest. My favourite pencils are 7B and 8B in the Mars Lumograph range produced by Staedtler, which are velvety black and smooth (they used to be called EB and EE). Watersoluble black graphite pencils are also available.

Pen and ink is a simple and responsive medium. A dip pen is the simplest of all, but if you are working away from home a reservoir pen like a fountain pen is a more sensible solution. In the past dip pens were made from materials like feathers, bamboo and reed. I sometimes use a quill pen or reed pen. Your sketchbook is a great place to experiment with these mark-making implements.

Some people use a ballpoint pen, an invention patented by the Hungarian journalist L. Biro in 1943. The ballpoint has a rather wiry, wet-ink line, and does not give the thicks and thins that you can achieve with a dip pen or fountain pen. However, it is convenient and cheap, and is a useful addition to your sketching kit.

Fibre-tip pens, such as the Edding 1800 range, are handy to use and come in various thicknesses of tip. I find them rather unforgiving for making marks as the weight of line is always constant. However, watersoluble fibre-top and felt-tip pens can give a soft effect.

I like to use a putty or kneaded eraser as they do not leave fragments of rubber on your work. Remember, though, that an eraser will not eradicate all marks if you have used coloured pencils or conté. Some pencils – such as the 7B I use – are quite waxy and will smudge.

Charcoal pencils are available in black, sepia, sanguine and white colours in soft, medium or hard grades. Blocks are useful to cover large areas, particularly if they are used on the flat side. With the softer pencils you will need a fixative to avoid the charcoal smudging. The choice of paper is important for charcoal work, although even brown wrapping paper will give some lovely qualities to your drawing. Experiment on different surfaces to find the paper that is most suitable for you.

You will need a good craft knife or penknife to sharpen your pencils; it will also allow you to shape the graphite for the thickness of line you wish to produce. A 'pen' knife was so called originally as this type of knife was used to cut a quill.

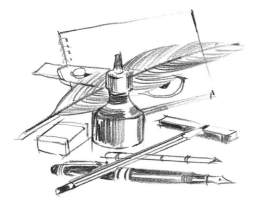

Tips:
🌢 To stop your ink spilling while out sketching, find a small flat box and cut a hole into the top for your ink bottle to stand in.

HARBOUR IN PORTUGAL
This quick sketch was made with watersoluble pencil, which I smudged with a wet finger.

ROUSSILLON
These two drawings were both done at the same time in Roussillon in the Luberon in France. The top one is fountain pen, the lower is done with a sanguine pencil.

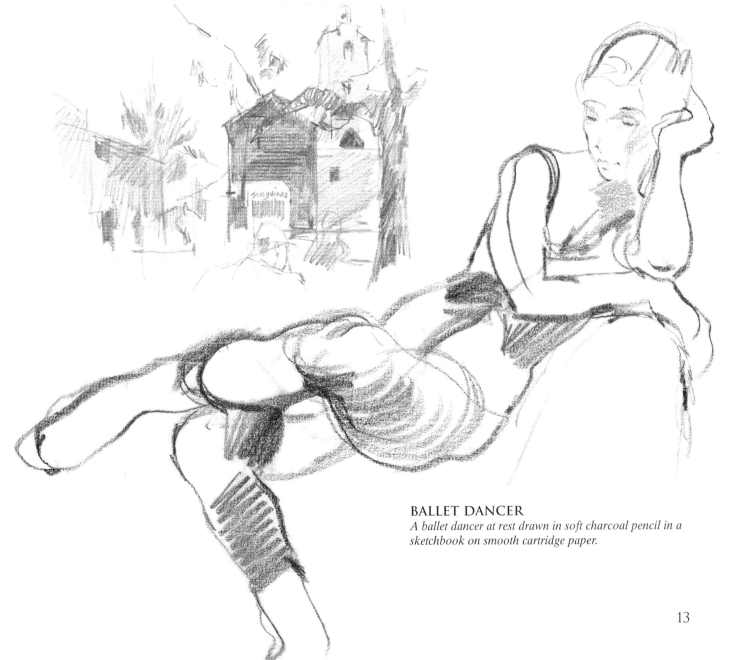

BALLET DANCER
A ballet dancer at rest drawn in soft charcoal pencil in a sketchbook on smooth cartridge paper.

13

I use all types of colour media for sketching, including watercolour, pastels, acrylics or oil pastels. These pages show a few examples of some techniques for using these materials. I tend to use watercolour paints with pencil or pen more than any other colour medium; they are often easier to transport and more convenient to use.

I often sketch directly with watercolour paints using a brush, or add washes of colour to pencil sketches as a useful aide-mémoire for more finished work at a later stage. A small box of watercolours with 10 to12 colours, either half or full pans, are part of my usual kit for sketching. Two or three good brushes are all you need in, say, sizes 5, 10 and 20; hand-made squirrel brushes are really good for holding water. My sketchbooks for watercolour are usually Arches Rough or H.P. paper, but there are many other types available and you will have your own personal preferences.

Acrylic or oil paints and oil bars can also be used and sketchbooks for these media are available already primed. Acrylics dry very quickly, but there are 'stay wet' palettes that are very effective for retaining the moist quality of the paint. To the other extreme, oils and oil bars can be mixed with an alkyd, a medium that speeds up the drying process, which makes it easier to transport your sketches. Turpentine will also thin the paint bars.

Use gouache paints, available in tubes, if you wish to add an opaque quality to your water-based sketches.

Pastels are a popular medium and you can choose from a huge range of colours with some varying degrees of softness. Sketchbooks with protective sheets are available especially for use with pastels: if you prefer not to use fixative, these books are certainly a very practical option.

Oil pastels are good to use and are available in positive, strong colours, though blending is more difficult unless you have turpentine handy.

Watersoluble and non-soluble coloured pencils are convenient to use and easy to slip into your pocket or sketching bag. They can be purchased either in sets, or individually.

LANDSCAPE IN SPAIN
This sketch in Spain was done with oil bars on to a ready-primed sketchbook. I used turpentine and Wingel alkyd to thin the paint. I scratched back into the wet paint with the end of my brush handle, a technique called sgraffito.

LANGUEDOC, SOUTH OF FRANCE

I first covered a piece of thick card with a red-brown ground and then painted the scene with loose brushstrokes with acrylic paints.

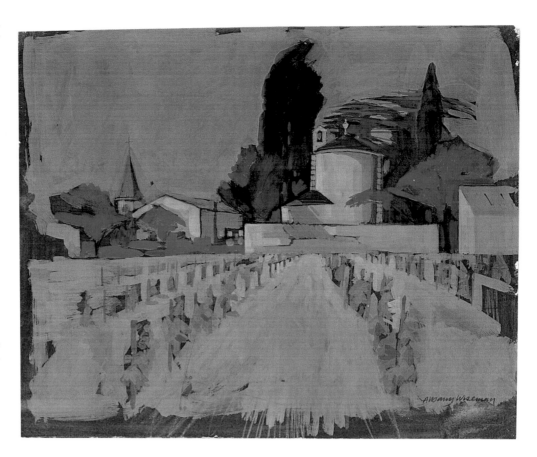

FITZROVIA, LONDON (below)

This sketch was done in watersoluble coloured pencils. The paper I used was a hard, smooth Schollershammer. I masked the blue area with tape so I could add the pencil freely and apply the wet areas with my finger, then scratched back with a sharp knife and the end of my pencil.

FRENCH DOORWAY

I later used this quick pencil and watercolour sketch of a doorway in a Luberon village to paint an oil of the same subject. This sketch was painted in a sketchbook with smooth H.P. paper.

BOATS AT COLLIOURE (left)

This bright oil pastel was made on Rough paper. I started drawing very freely with a black felt-tip pen. I was initially attracted by the bright colours of the boats and have deliberately enhanced that quality in the drawing.

CHAPTER 2
PEOPLE

The figure is an important subject for the artist – and one that I have been concerned with since I was a student. My sketchbooks are full of drawings of friends, models, commissioned subjects and strangers observed in bars, on boats, or occasions such as sports events. There are even sketches of long-forgotten cronies from my army days.

When I was at art school figure drawing was an important and compulsory part of the curriculum, and every student spent time in the life room. Life drawing went out of fashion in the 1960s, but it appears to be making a comeback. It seems to me that as human beings we should be curious about our own kind, and I also feel that if you can master depicting the figure you are quite capable of drawing anything.

There is great value in introducing the figure into a drawing – not only does it give scale to a picture but also life and animation. Skill in drawing the figure comes from observation, an understanding of anatomy and the proportions of the body, and above all, practice. In time you will be able to draw figure shapes from memory. And the best place to practise your skills is in your sketchbook.

LAGOS MARKET (above)
I have visited this part of Portugal several times and enjoy the hustle and bustle of the weekly market. This sketch was made in a large pad using an 8B pencil and a vigorous line.

SAN MARCO, VENICE
This tiny sketch (13 x 9cm, 5 x 3½in) was made in the tourist-thronged square in front of St Mark's in Venice. I liked the stocky figure, the solid stance and the bulky layers of clothing of this woman selling pigeon food. I used an 8B pencil and watercolour on her garments, placing a splash of gold for the grain on her stall.

ODETTE
*I sketched this model in a
drawing class. The sketch was
completed in pencil on
cartridge paper.*

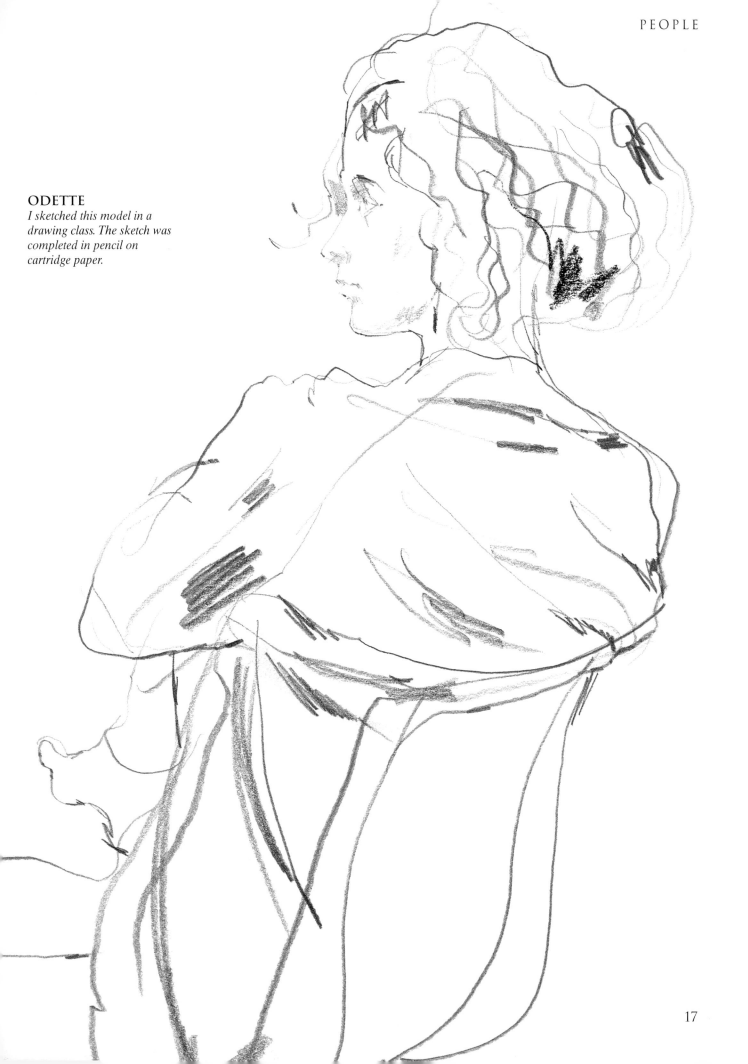

LIFE DRAWING

A life drawing class is a wonderful way of learning about the figure, but many well-known artists have been self taught. If it is not possible to attend an art college or life class there are other ways of teaching yourself. You can learn a lot about the skeleton and surface muscles by studying a book of anatomy. Draw friends and family whenever you can – people watching television are invariably static models. Of course, you can always draw yourself in a mirror – plenty of fine artists have used themselves as models. However, if you are to really study and understand the figure you need to work from a model. Try getting a group together so that you can hire and share a model, and keep all your sketchbooks and notes to remind you of your progress.

IN THE STUDIO (below)
I dropped in to a friend's life class at a studio in Chelsea and found that the model had failed to turn up. The tutor suggested that the students draw the class – a challenging, but fascinating, subject. I particularly liked the way the verticals and planes of the easels and drawing boards provided an underlying geometry that contrasted with the more fluid forms of the seated and standing figures. A painting class provides a good opportunity to study the human figure since the students are in many different poses and remain relatively still. I used a Staedtler Lumograph 7B pencil, which is black and waxy.

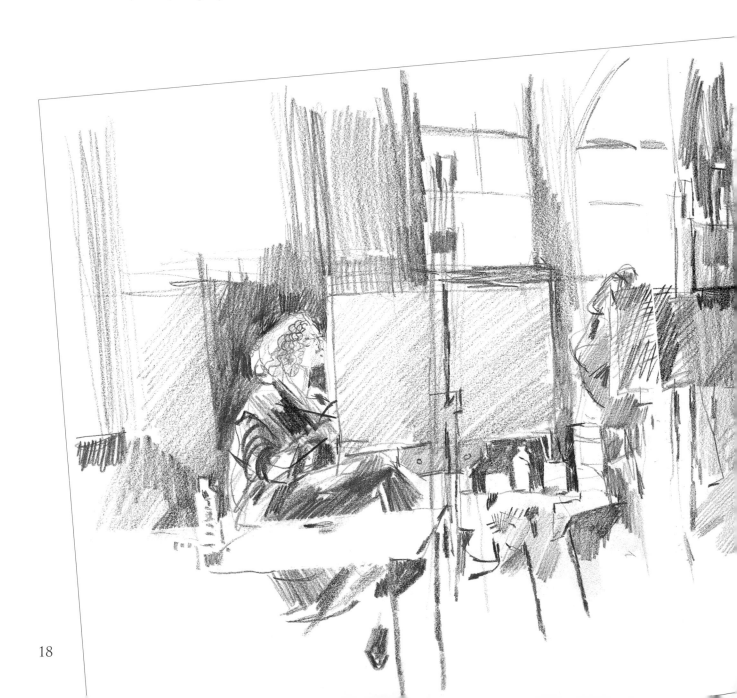

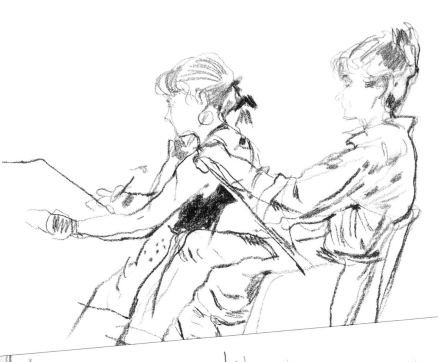

LIFE CLASS
Two students intent on their drawing in a life class. I sketched them with a charcoal pencil on a smooth cartridge paper.

Tip:

❁ Use the verticals, horizontals and angled lines of the subject and its background as a grid on which to locate the elements of your sketch. Use the 'negative spaces' between objects to check the accuracy of your drawing.

MUSICIANS

Musicians make good subjects to draw in your sketch-book. As soon as a musician picks up his instrument or sits down to play it he or she adopts a position that is dictated by its shape, size and location, and the method of playing.

Try drawing someone at the piano or playing the guitar, or your child doing their violin or recorder practice. Notice how specific the poses are. Each musical instrument requires a characteristic stance and a series of attitudes, and it is important to get this stance right and the way that the instrument is held, and to portray the particular relationship between it and the musician.

The hands of a musician are a crucial element, but in many ways they are the most difficult part of the anatomy to draw. To practise drawing hands draw your own opposite hand, or use a mirror. Draw foreshortened angles, then try sketching your hand holding a glass, a cup or a book.

The span or spread of fingers of someone playing an instrument such as the guitar can make a study in itself. I was flattered when one of my subjects said how good it was to see that the 'hands were right', but it reminded me how important it is to look carefully and draw accurately, especially with stringed instruments.

BILL LOVELADY, WATERCOLOUR
Bill is a gifted guitarist and agreed to pose for me when we met in Spain. I worked directly, drawing with a brush and watercolour wash on a Rough watercolour paper. The technique allowed me to work quickly to achieve the solidity and volumes of the figure. The strings of the guitar were scratched in with the tip of a craft knife.

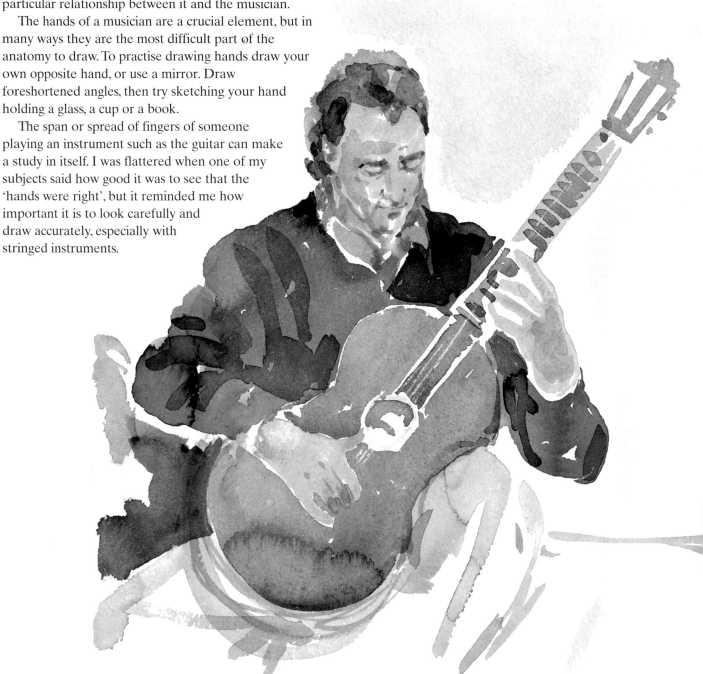

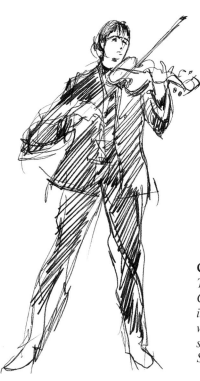

VIOLINIST
This tiny sketch using a Mont Blanc fountain pen was made during a concert.

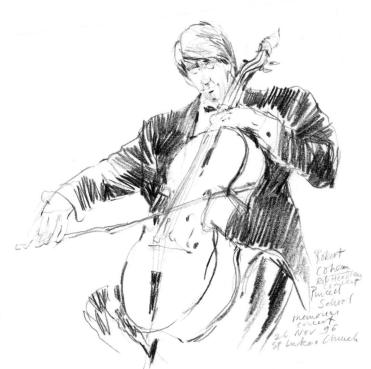

CELLO PLAYER
The musician is Robert Cohen, who has an international reputation. He was performing at a memorial service given by the Purcell School of Music in London.

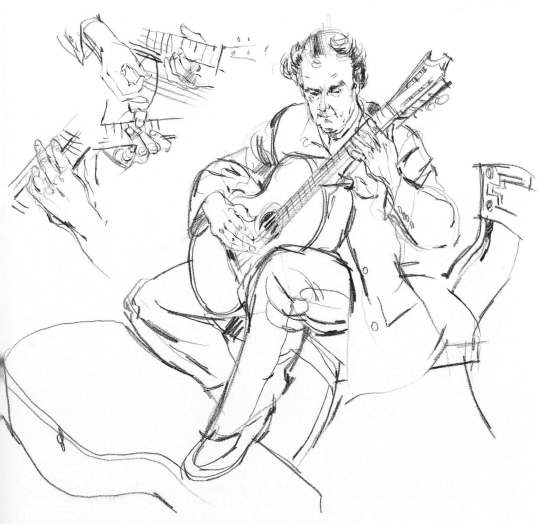

BILL LOVELADY, PENCIL
I made this study in my studio in London. I used a 10B pencil, working broadly and boldly, and paid special attention to the slope of the shoulders, the angles of the arms and legs, and the details of the instrument and the hands. As you can see, I made several detailed studies of Bill's hands at the top of the page – it was a marvellous opportunity to see hands being employed in pursuit of a very specific purpose.

THE WORKPLACE

Your place of work, whether it is an office, a factory or a delivery van, can be a wealthy source of visual images and inspiration. Get into the habit of keeping a small sketchbook in a drawer or a pocket, and use your lunch breaks and tea breaks to make sketches of your colleagues as they go about their everyday tasks. While people are concentrating on what they are doing they will be unaware of your scrutiny, and you will find plenty of interesting poses that involve bending, stretching, lifting and walking. The interaction between individuals and groups of people, and between individuals and groups and their surroundings, is also interesting. Try to include some of the background in your sketch as it will give the drawing a context and a sense of scale.

The drawings illustrated here were sketched in industrial workplaces. I had to position myself so that I could see what was going on without getting in the way, and I wore a hard hat for safety.

FIRTH'S WOOLLEN MILL, SHEPLEY (right)
This sketch was made some years ago for the cover of a telephone directory. At the time the telephone company was commissioning illustrations of topographical subjects, which were often very interesting to draw. The noise and clatter of this warping machine was indescribable. I have included a lot of detail, though some of it was edited out in the final drawing to produce a simpler, more graphic image that would have impact on a cover.

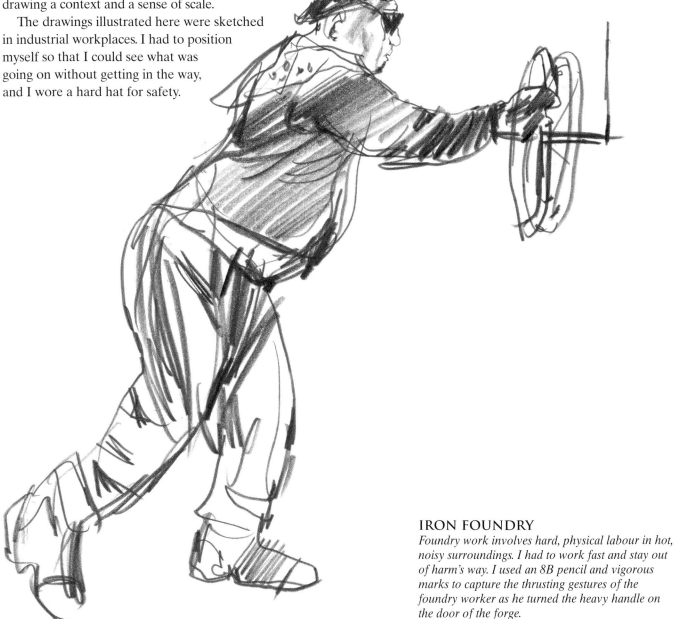

IRON FOUNDRY
Foundry work involves hard, physical labour in hot, noisy surroundings. I had to work fast and stay out of harm's way. I used an 8B pencil and vigorous marks to capture the thrusting gestures of the foundry worker as he turned the heavy handle on the door of the forge.

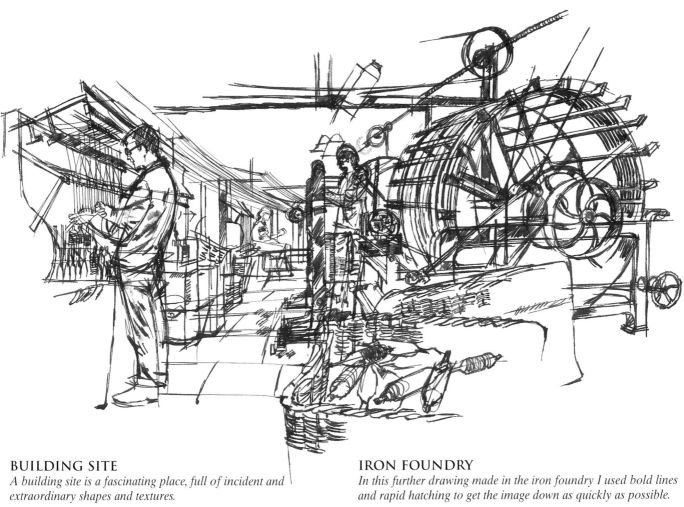

BUILDING SITE

*A building site is a fascinating place, full of incident and
extraordinary shapes and textures.*

IRON FOUNDRY

*In this further drawing made in the iron foundry I used bold lines
and rapid hatching to get the image down as quickly as possible.*

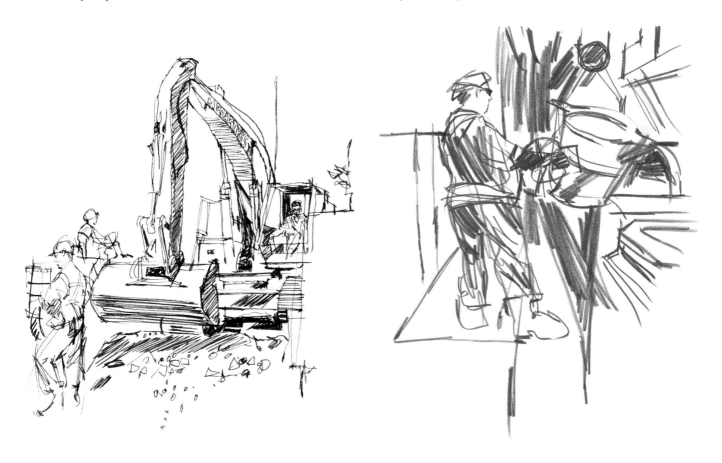

THE MOVING FIGURE

The figure in movement can seem daunting to sketch. The trick is to start working immediately, drawing what you see and not worrying about the results. You must learn to simplify the forms and find the lines that sum up the movement. The first few pages of sketches allow you to get your hand and eye in, rather like warming up before sports or gymnastics. After that the images will begin to emerge quickly and fluently and you will be surprised how convincingly you have captured a movement. Your eye acts like a camera, freezing a sequence of movements, so that you are actually drawing from memory. Whenever the figure is in action, whether walking, running, playing a sport or dancing, you will find that certain movements are repeated regularly, and as they become increasingly familiar you will find them easier to draw. The more you sketch the better your visual memory becomes – and the improvement is satisfyingly fast.

Tip:
* Work in a large sketchbook so you can make several studies on a single page.

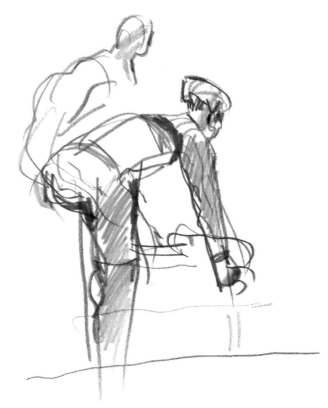

ON THE TRACK (above and below)
My brother and I went to watch some international cycle racing. This is a fascinating subject for the artist, combining speed, vibrant colour and a variety of shapes. The hunched, intense forms of the competitors, the sculptural, aerodynamic shapes of their helmets, and the ellipses, circles and angles of the machines provide plenty of challenging material. Bicycles are actually quite difficult to draw, so it is worth making studies when you have the opportunity.

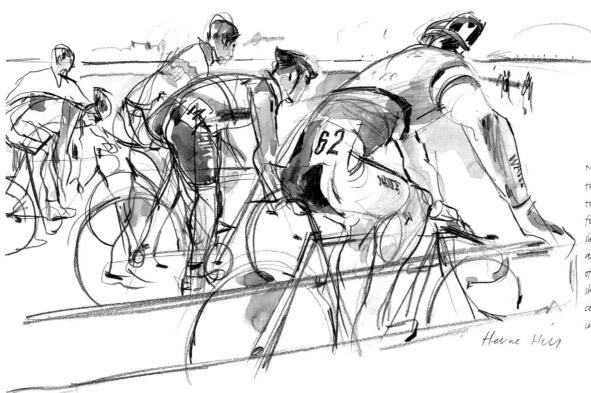

Notice the way the hoops on the shirt curve round the torso, giving it volume and form. In the same way the sleeves curve round the arm and the shorts hug the curve of the thigh. When time is short you have to isolate and concentrate on the most important features.

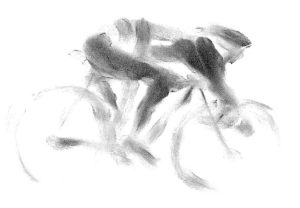

CYCLING AT HERNE HILL, SOUTH LONDON

The need to get an image down in seconds can make you very inventive. On these two pages I show three different techniques for drawing the figure in motion. The sketches on the opposite page were made in pencil, while the cyclists above were slicked in with a charcoal-covered finger – I think this captures the sense of speed. The cyclist on the right was made directly in watercolour with no preliminary drawing at all.

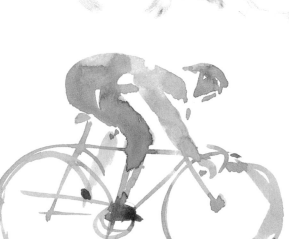

SANDOWN PARK

The hustle, bustle and excitement of the racecourse presents plenty of opportunity to study people as they unselfconsciously adopt fascinating poses. The arcane sign language of the ticktack men is something you simply could not dream up in the studio. Here, the repeated and graceful curves of the umbrellas give the image a sense of rhythm. I am also always fascinated by lettering in the environment and pay special attention to it.

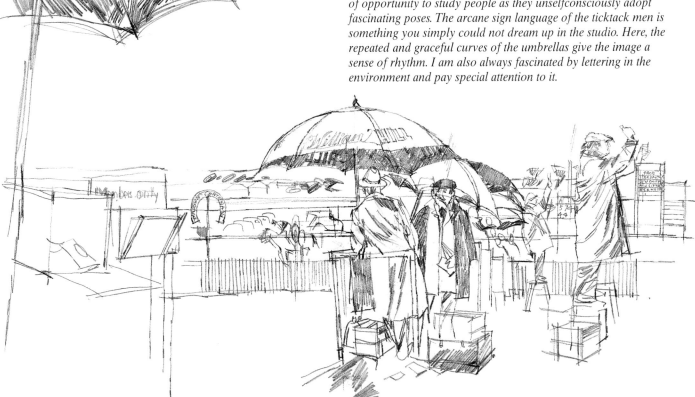

SPORTS PLAYERS

I have always been fond of sport and it is hardly surprising that sporting occasions feature throughout my sketchbooks. More than anything practice is the key to success when you are drawing the figure, and any sports activity offers you brilliant opportunities to study the human form in action. Work quickly and do not be afraid of making 'mistakes'. You will soon notice that each sport has a fairly limited range of actions and movements that are repeated frequently – for instance, a tennis player's body extended in a service, a cricketer hunched over his bat, a boules player's arm stretched forward as the ball leaves his hand and the other arm stretched back in a counterbalancing gesture. In fact, most sports incorporate moments of tension and fleeting balance that are reminiscent of dance.

Recognizing and remembering these characteristic movements will enable you to complete the drawing when the moment of action has passed.

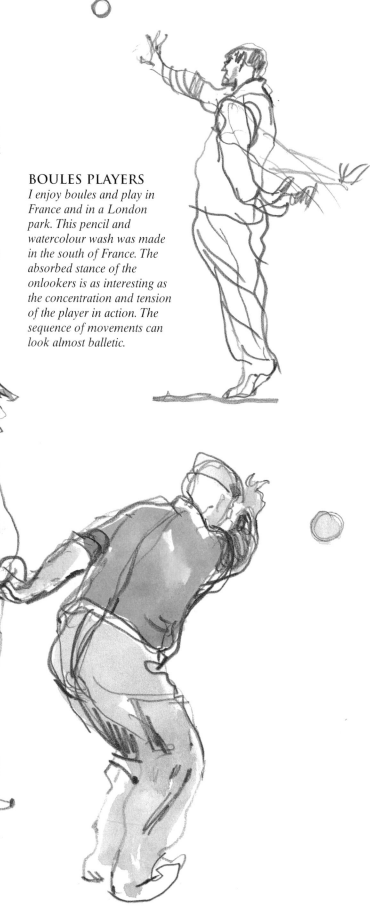

BOULES PLAYERS
I enjoy boules and play in France and in a London park. This pencil and watercolour wash was made in the south of France. The absorbed stance of the onlookers is as interesting as the concentration and tension of the player in action. The sequence of movements can look almost balletic.

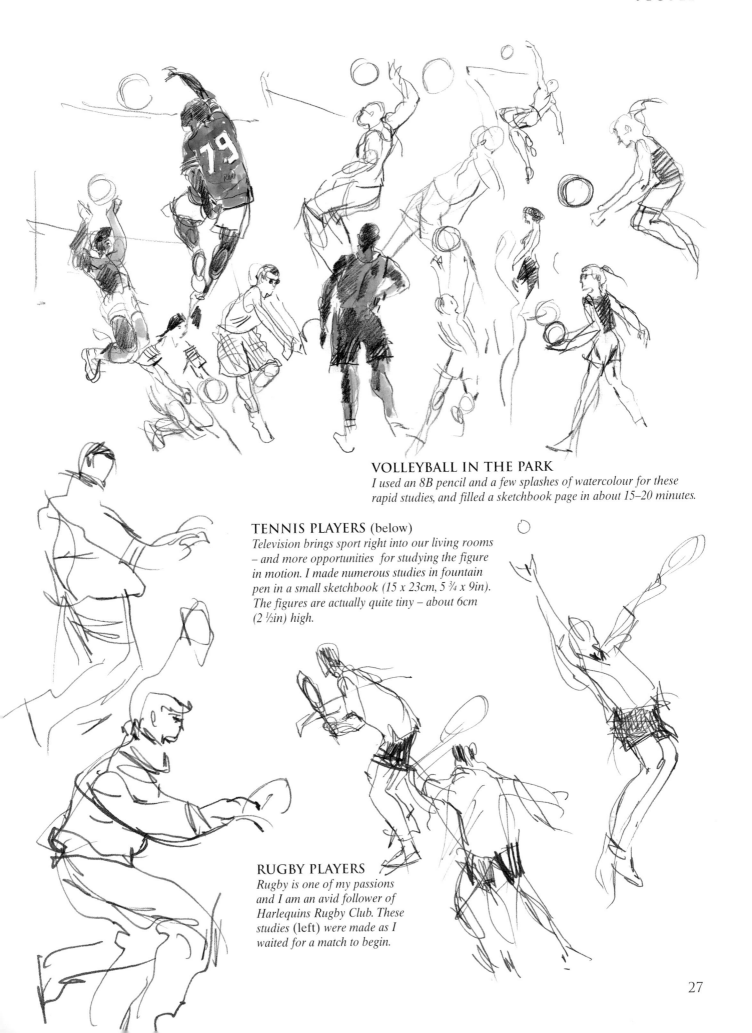

VOLLEYBALL IN THE PARK
I used an 8B pencil and a few splashes of watercolour for these rapid studies, and filled a sketchbook page in about 15–20 minutes.

TENNIS PLAYERS (below)
Television brings sport right into our living rooms – and more opportunities for studying the figure in motion. I made numerous studies in fountain pen in a small sketchbook (15 x 23cm, 5 ¾ x 9in). The figures are actually quite tiny – about 6cm (2 ½in) high.

RUGBY PLAYERS
Rugby is one of my passions and I am an avid follower of Harlequins Rugby Club. These studies (left) were made as I waited for a match to begin.

DANCERS

I enjoy drawing dancers of all kinds. I love the excitement of flamenco, the grace and control of classically trained ballet dancers, and the happy abandon of people 'doing their own thing' at parties and jazz clubs. Drawing from dancing figures is challenging and takes practise, but it is a wonderful way of learning to understand movement. Because the gestures are graceful but exaggerated it is relatively easy to find and note down the key rhythms and lines. I look for the lines that sum up the movement, and commit poses and gestures to memory so that I can complete the drawing when the moment has passed.

Each drawing should imply transition and also the completion of the movement – something has only just happened and something is about to happen. The speed at which everything occurs forces you to concentrate, make decisions and work quickly so that inevitably you will hone your powers of observation and the speed with which you work.

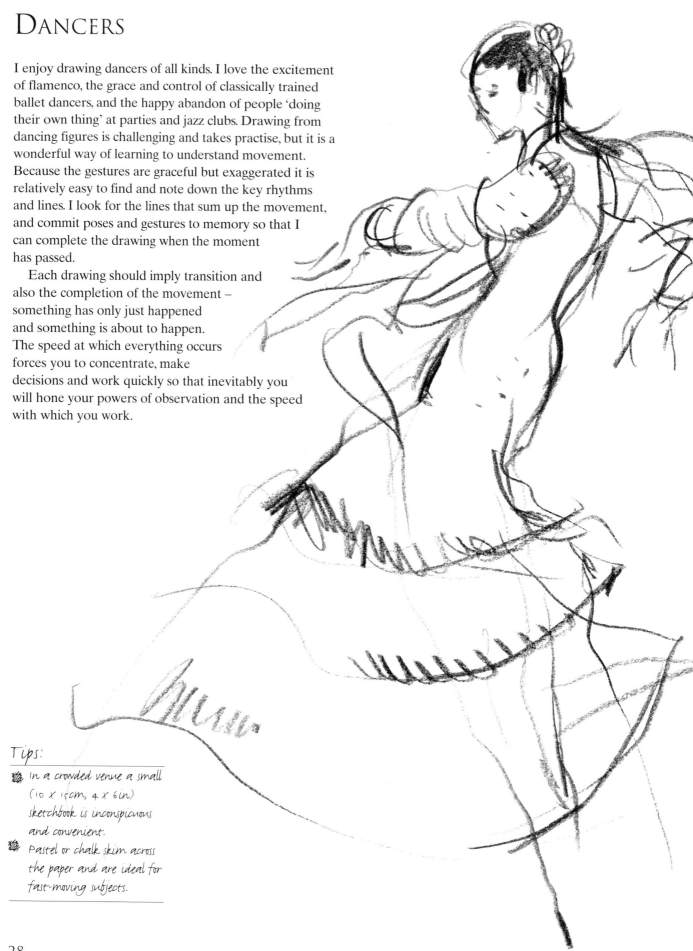

Tips:
* In a crowded venue a small (10 x 15cm, 4 x 6in) sketchbook is inconspicuous and convenient.
* Pastel or chalk skim across the paper and are ideal for fast-moving subjects.

28

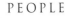

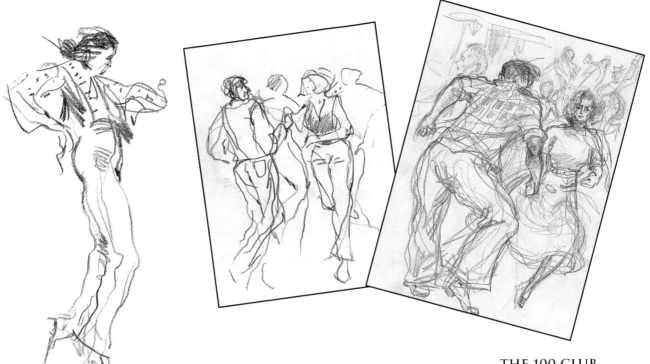

FLAMENCO DANCERS (left and above)
These sketches were made in a crowded tapas bar. I wanted to capture the characteristically exaggerated movements of Spanish dance – the rhythm of the dance and the snapping of the castanets helped the drawings to flow.

THE 100 CLUB
The drawing top right was made in 1949 – the other was made at the same venue 50 years later! On both occasions I worked in small sketchbooks and used pen and pencil to record the swiftly moving figures, trying to capture a sense of noise, bustle and fun.

BALLET
A professional ballet dancer went through a sequence of traditional poses in slow motion for me in the studio. This gave me time to make several rapid sketches and analyse the way one movement flowed into the next, capturing the solidity of the forms without worrying about details. The drawings were made using a 7B pencil and grey, sanguine and black pastels.

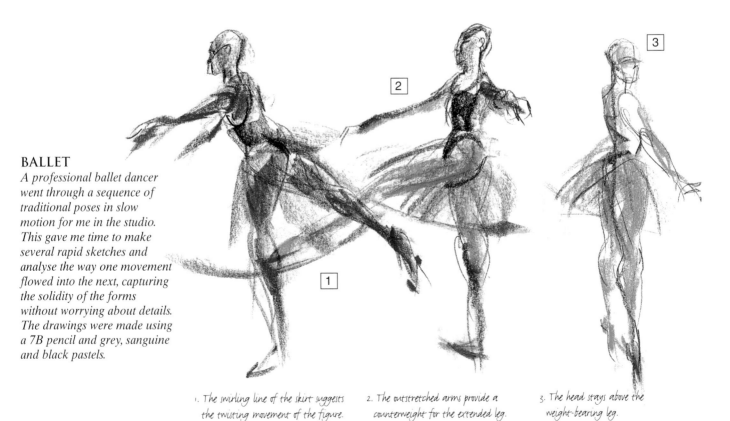

1. The swirling line of the skirt suggests the twisting movement of the figure.

2. The outstretched arms provide a counterweight for the extended leg.

3. The head stays above the weight-bearing leg.

TRAVEL – THE FIGURE OBSERVED

With your sketchbook as a close companion you are ready to make a record of a time and a place, even when you are in transit. Find a quiet corner; it can be disconcerting to have somebody looking over your shoulder even though their curiosity is understandable. A camera is an alternative, but it is much more intrusive. Most people are happy to be drawn, but many view a stranger pointing a camera at them as intimidating and rude. If you are spotted drawing your subject they may adopt a 'pose', adjusting their hair or hiding their double chin, or they may ask for the finished sketch.

Scotland is one of my favourite places and I was fortunate to be commissioned to make a series of illustrations of locations throughout the country, so I bought a second-hand camper van and headed north. The van gave me mobility and provided accommodation in an emergency, but its most important function was as a mobile studio, offering shelter in the not infrequent inclement weather. The back of the van was roomy, with plenty of headroom and a reasonable work surface – what else could I wish for?

This assignment presented particular transport and shelter problems, but I have always used my car as a studio. Cars are criticized for the pollution they cause, and for the proliferation of roads and motorways that spread across the countryside, but there is no doubt that they also offer great convenience. They give you the freedom to travel in comfort, warmth and shelter, and you can carry as much kit as you want. A non-motorized sketcher has to do more planning.

THE FERRY TO STORNAWAY

It was fresh and blustery up on deck, but the raw material was compelling: sea and sky, the complex superstructure of the boat, the great red pyramid of the funnel, and people – sitting, standing, looking and going about their chores. I made myself comfortable in a relatively sheltered spot and worked in pencil on a large pad (30 x 38cm, 12 x 15in). I completed the image with a few loosely applied washes.

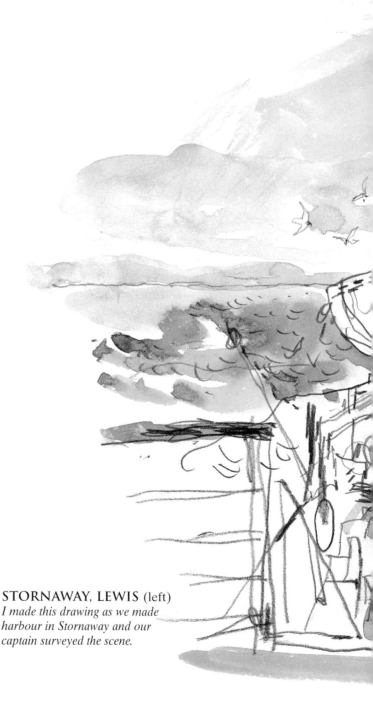

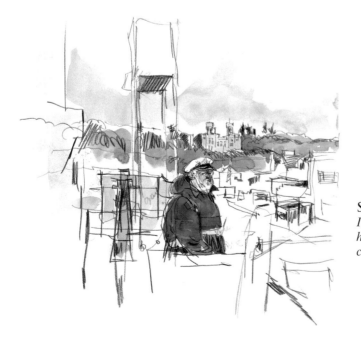

STORNAWAY, LEWIS (left)
I made this drawing as we made harbour in Stornaway and our captain surveyed the scene.

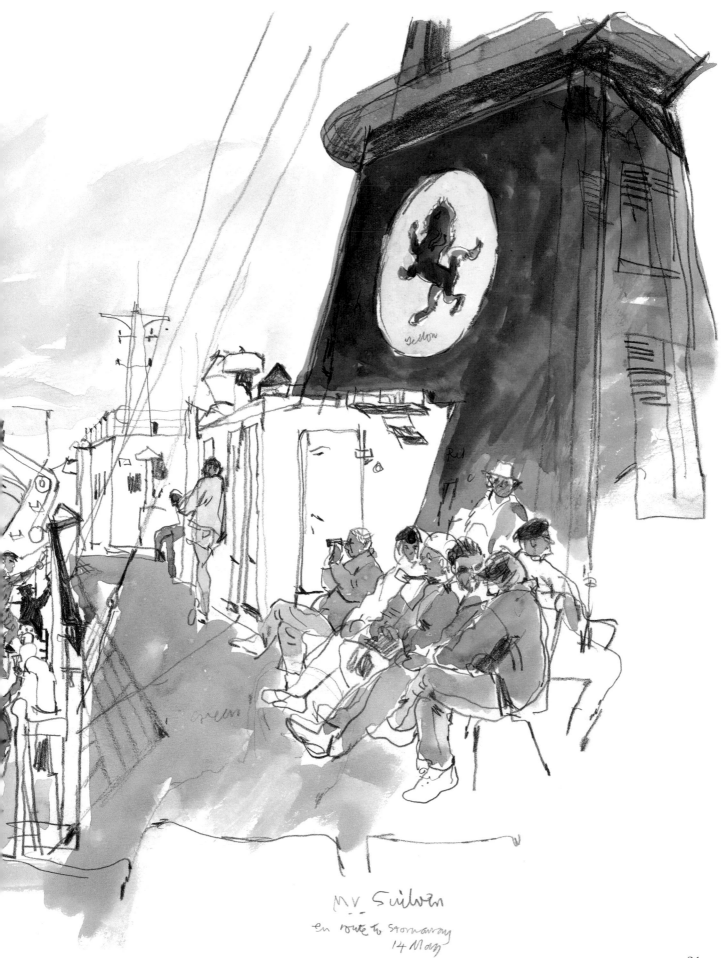

MV Suilven
en route to Stornoway
14 May

DRAWING IN A CROWD

Sketching in a crowded place can be difficult and daunting, but there is no better way of studying people doing things and interacting with each other. Sketches made in these situations have an anecdotal quality. They are full of movement and atmosphere, unusual characters, interesting poses and expressive gestures. Find a private corner where you will not be jostled and, where possible, hide behind a newspaper, a cup of coffee or a glass of beer. If you blend into the surroundings you will feel relaxed and your subjects will not notice what you are up to. Use a small sketchbook to be unobtrusive and keep your materials simple for the same reason. A pen or a pencil, a pencil sharpener and an eraser are all you need.

Sketching is about observing really well and identifying the telling details, such as a fold, a profile, or a gesture. Work quickly, do not hesitate and do not be afraid of making a mark. Some of your lines will be inaccurate but it does not matter – you are 'allowed' to take risks and make mistakes in your sketchbook. And remember, the more you practise sketching in crowded places the more your confidence in drawing will grow.

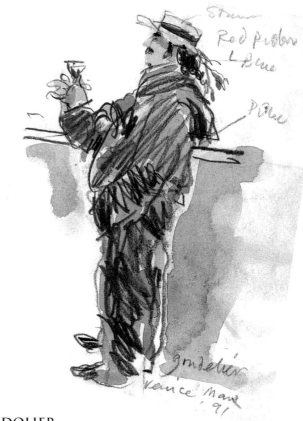

GONDOLIER
This quick annotated sketch is tiny (13 x 9cm, 5 x 3½in) and was made with a 10B pencil, with simple washes of colour applied over.

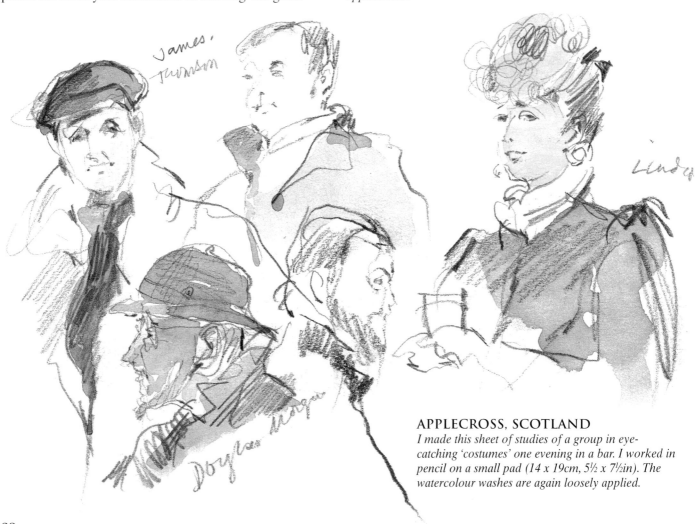

APPLECROSS, SCOTLAND
I made this sheet of studies of a group in eye-catching 'costumes' one evening in a bar. I worked in pencil on a small pad (14 x 19cm, 5½ x 7½in). The watercolour washes are again loosely applied.

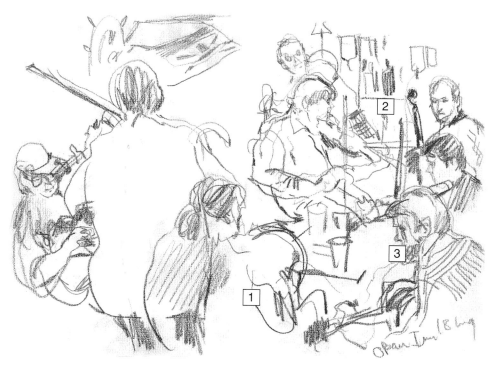

BAR IN OBAN

The evening was full of noise and music as people brought their instruments and spontaneously joined in with the music making in a very crowded pub in Scotland. There was a fiddler, a guitarist, and a man playing a bodhran drum. I had a small sketchbook in my pocket and a 10B pencil and stood in a corner to make the sketch. I drew very freely, without much detail, the pencil dancing across the rough Italian paper to create a softly broken line that is expressive and full of vigour.

1 Do not be afraid of taking the image across the gutter.
2 Details such as the tartan pattern of the barman's kilt take seconds to put in.
3 Try and get the correct stance of the musicians, as well as their relationship to their instrument.

TAPAS BAR, SEVILLE (right)

This small, detailed study was made in a bar in Spain. I was fascinated by the typical decorated tiles – and I notice that I have given the menu in detail.

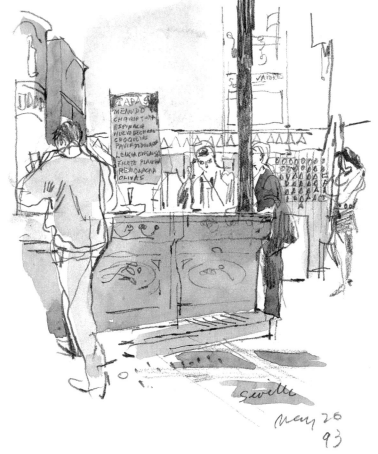

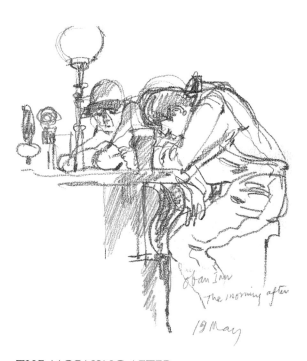

THE MORNING AFTER

This scene greeted me the morning after the ceilidh!

RESTAURANTS AND BARS

Sketching in a busy bar can be unnerving if you are shy about being watched as you draw, but this is just the sort of place where people are so absorbed in themselves, their companions, their food or their paper that they simply will not notice what you are up to. And there is no better way of seeing a variety of people posing unselfconsciously, from the businessman hunched over his lunch to the waitress slipping deftly through the throng, balancing a perilously loaded tray. It would be almost impossible to achieve this variety and excitement in the studio, and a camera is no substitute – by freezing a moment a photograph does too much of the selection for you, preventing you seeing and understanding the development of a movement, a gesture, or an interaction.

The most fascinating figure studies are undoubtedly those that are made from everyday life. They are often full of varied and unusual characters, expressive gestures and incidental details, and the best sketches manage to capture the mood of the place.

Ensconce yourself in a quiet spot where you are not too overlooked – a corner spot is ideal. Order a beer or coffee as camouflage, and survey the scene. Work in a small pocket-sized sketchbook – 15 x 10cm (6 x 4in) is a useful size – and use a simple drawing tool that you feel comfortable with. Pencil, fountain pen, fibre-tipped pen and ballpoint are all useful for sketching. I always have a pencil and a fountain pen with me.

Draw quickly and confidently, looking for broad shapes and lines that seem to sum up a gesture or movement. Include information about the context to give the drawing a sense of space and scale. Make notes of details such as furniture and light fittings; these will give the sketch a sense of place. I often include lettering, which forms a significant part of the visual environment. It appears on shop fronts, chalkboards, safety and directional signs and menus, and because styles change you will find that it is generally an extremely good clue to location and also to time.

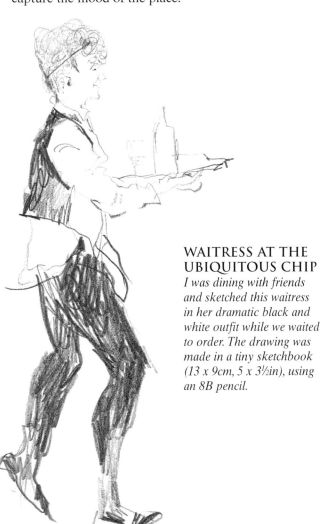

WAITRESS AT THE UBIQUITOUS CHIP
I was dining with friends and sketched this waitress in her dramatic black and white outfit while we waited to order. The drawing was made in a tiny sketchbook (13 x 9cm, 5 x 3½in), using an 8B pencil.

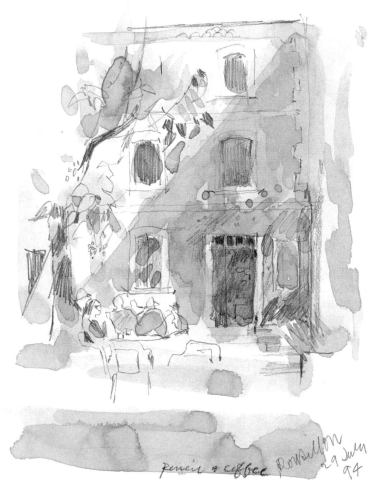

VILLEFRANCHE SUR SAÔNE, FRANCE
(right and below)
The drawing below was made in August 1950 in pen and ink, coffee, and red wine! In August 1995 I was passing the same spot and sat at the same restaurant, and completed the drawing shown on the right in fountain pen and coffee.

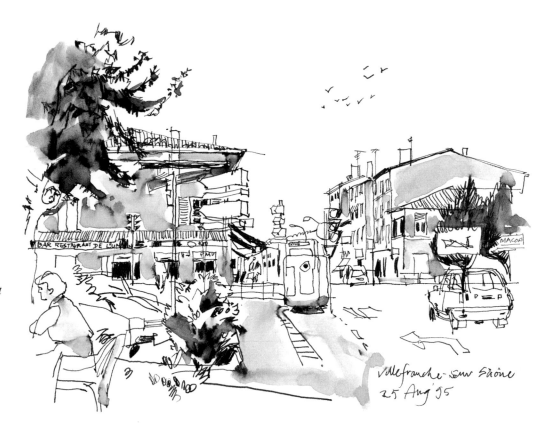

WAITERS AND WAITRESSES
Moving figures are a real challenge – you have to train yourself to memorize a pose so that you can complete it after the person has moved on. This takes practice, but with application anyone can acquire the skill.

PENCIL AND COFFEE IN ROUSSILLON, FRANCE (left)
Some people make a great fuss about their art materials, and claim that they cannot work unless they have everything just so. More often than not that is simply an excuse for doing nothing. In reality there is almost always something you can draw on and with, and there are many stories of great artists being reduced to sketching on napkins, tablecloths and restaurant menus. I am very fond of coffee, and here I have used it to add a sepia wash to this pencil drawing.

BABIES AND CHILDREN

Children are an absorbing and fascinating subject to
sketch, especially for a parent or grandparent. And what
could be a better memento of childhood than a
sketchbook that records the daily events, the lumbering
crawl, the tottering walk and the blissful peace and quiet
of a slumbering child. If you are a doting parent or
grandparent, why not set aside a sketchbook especially
for child studies? It will be a wonderful source of
inspiration and a magical souvenir of those precious and
all too fleeting childhood years.

MATTHEW

*I persuaded Matthew to pose
for me, and he was a very co-
operative and patient model.
Nevertheless I worked fast,
using a 7B pencil on grey
Ingres paper. I added some
touches of colour with coloured
pencil. I used my pencil as a
measuring implement to check
that the proportions of the
figure were correct.*

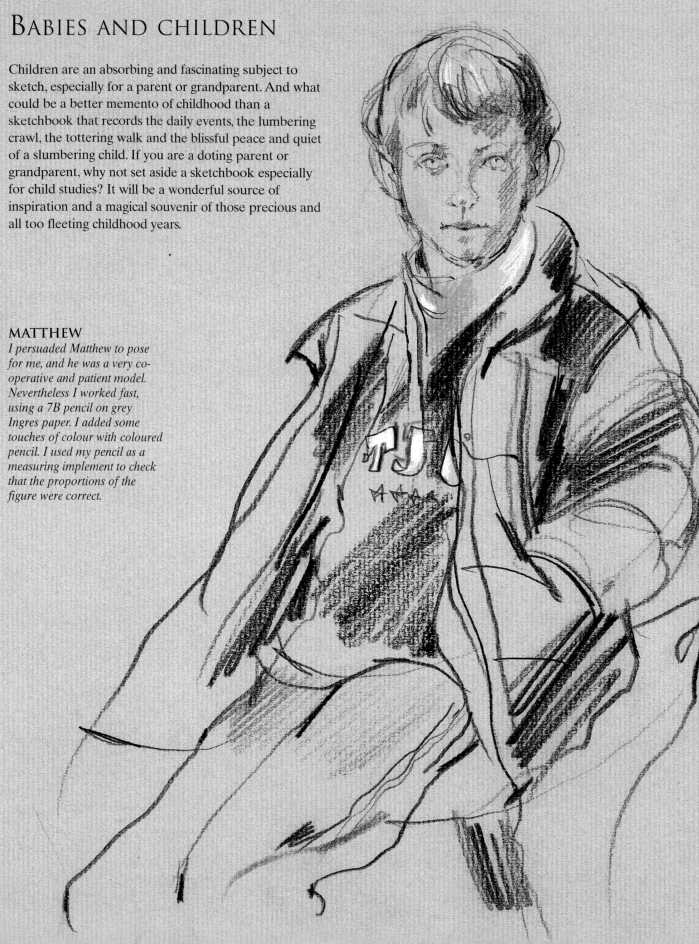

As soon as you start sketching children you will find that they are not simply scaled-down adults: they are an entirely different shape from adults and have different proportions. A newborn baby has a relatively large head in proportion to the rest of the body. At a year old the head is still quite large compared to the rest of the body,

and the legs are relatively short; at this point the child's head will fit into its body almost five times. By the age of eight the head has grown a bit, but the body has grown more and the head fits into the body just over six times. These are guides only, since individual children grow at very different rates.

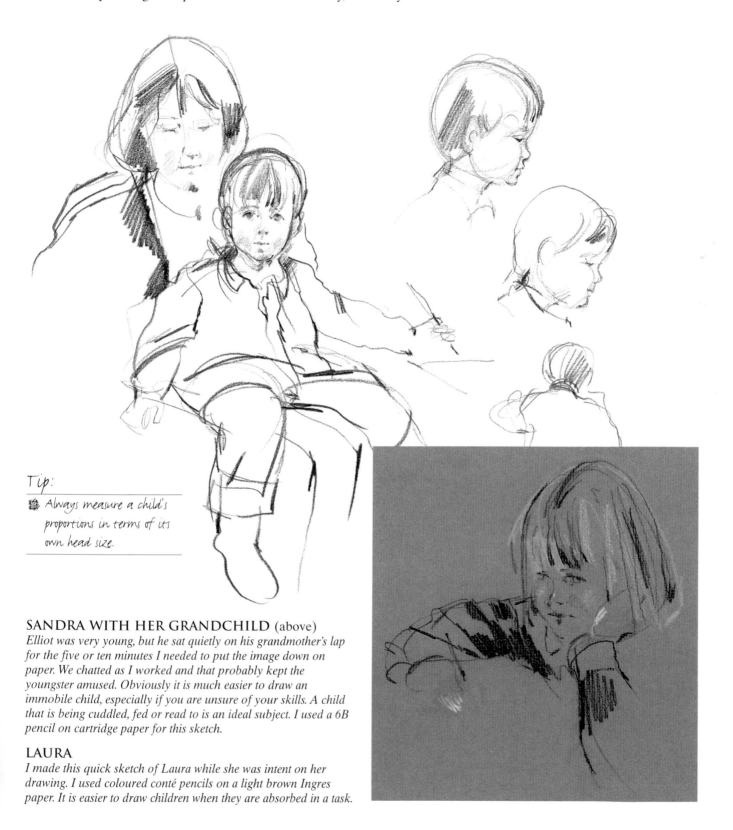

Tip:
* Always measure a child's proportions in terms of its own head size.

SANDRA WITH HER GRANDCHILD (above)
Elliot was very young, but he sat quietly on his grandmother's lap for the five or ten minutes I needed to put the image down on paper. We chatted as I worked and that probably kept the youngster amused. Obviously it is much easier to draw an immobile child, especially if you are unsure of your skills. A child that is being cuddled, fed or read to is an ideal subject. I used a 6B pencil on cartridge paper for this sketch.

LAURA
I made this quick sketch of Laura while she was intent on her drawing. I used coloured conté pencils on a light brown Ingres paper. It is easier to draw children when they are absorbed in a task.

MORE CHILDREN

Children have very special qualities. Notice, in particular, the lovely translucency of their skin, the roundness and softness of their limbs in the early years, and their incredible alertness and vitality. Even their facial proportions are different from those of an adult, with a large forehead, a small nose, mouth and chin, a soft, undefined jawline and relatively large ears. Hair can be very characterful, ranging from a few thin wisps to an unruly mop.

Drawing a moving child is always a challenge. Start by drawing children at play, or absorbed in a task such as eating or bathing, or best of all when they are asleep. When you are more confident you can try drawing children running around. Work on a large sheet of paper and concentrate hard to commit the pose to memory so that you can complete the drawing even when the action changes. Make several drawings on a single sheet; you may find that the child returns to an earlier pose and you can add details or finish an incomplete study.

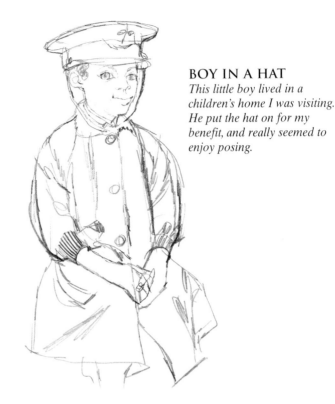

BOY IN A HAT
This little boy lived in a children's home I was visiting. He put the hat on for my benefit, and really seemed to enjoy posing.

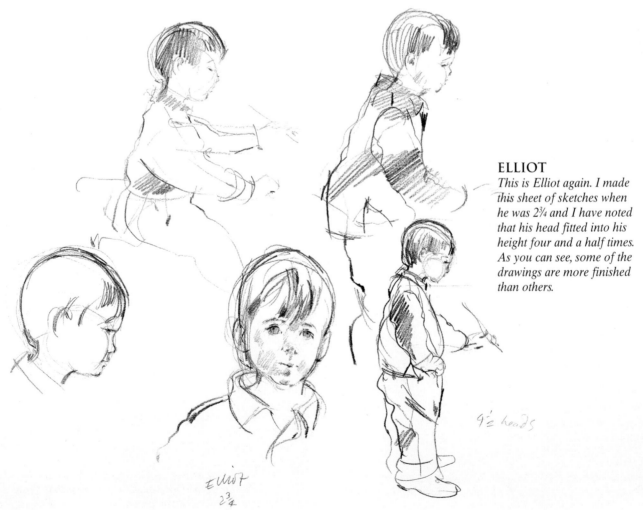

ELLIOT
This is Elliot again. I made this sheet of sketches when he was 2¾ and I have noted that his head fitted into his height four and a half times. As you can see, some of the drawings are more finished than others.

4½ heads

Elliot
2¾

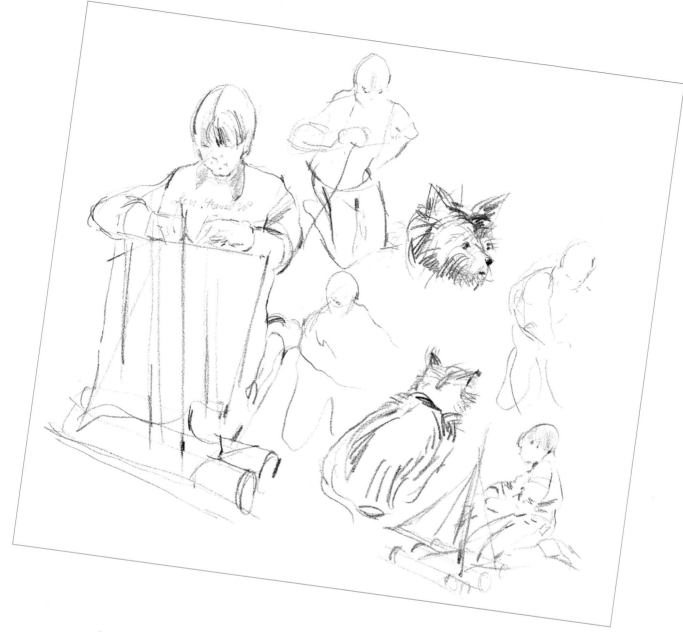

ALEXANDER BUILDING A BOAT (above)

This sheet shows Alexander building a boat from cardboard tubes, watched by Basil, a Norwich terrier. The boy's pose was constantly changing as he wrestled with the components. The relationship between an individual and the object they are working on, or with, is always interesting, and it is important to include enough information of what they are doing to make sense of the pose.

CHILDREN AT WORK

Here I have captured different children at different tasks – Marina practising on her recorder is one, and Alexander doing his homework is another. They were oblivious of me, so I could get on with sketching them unobserved. Children will sometimes pose if they are asked, or bribed even to do so, but generally they become bored very quickly, so it is much better to try and catch them unawares.

FROM SKETCH TO FINISHED PAINTING: MARKET DAY

I have sketched the hustle and bustle of the weekly market in Lagos, Portugal, many times. On this occasion it was a hot day and I had only a few minutes to spare, so I found a shady spot where I could stand with my back against the wall, away from the jostling crowd. Working quickly I concentrated on getting the stances of the market traders, the shoppers, and the emphatic shape of the black-garbed woman in the centre of the composition. Sketching when people are constantly moving about is difficult at first, but with practice you will find it easier to commit poses to memory so that you can complete the drawing after the person has moved on. Sometimes people linger for a moment, or return to the same pose, and you can complete a drawing you started earlier.

Time was short, so I had to restrict myself to the most important details. I used quite a large sketchbook – 38 x 30cm (15 x 12in). The large page gave me space to make marginal studies of figures and background details such as the crates of fruit and the weighing scales. There was a wonderful selection of hats and caps perched at odd angles on the heads of the men; quirky details like this give a drawing character. I used my favourite 7B pencil, which gives a good black line, and washed in a little watercolour. The colour reference was useful when I developed the painting some time later.

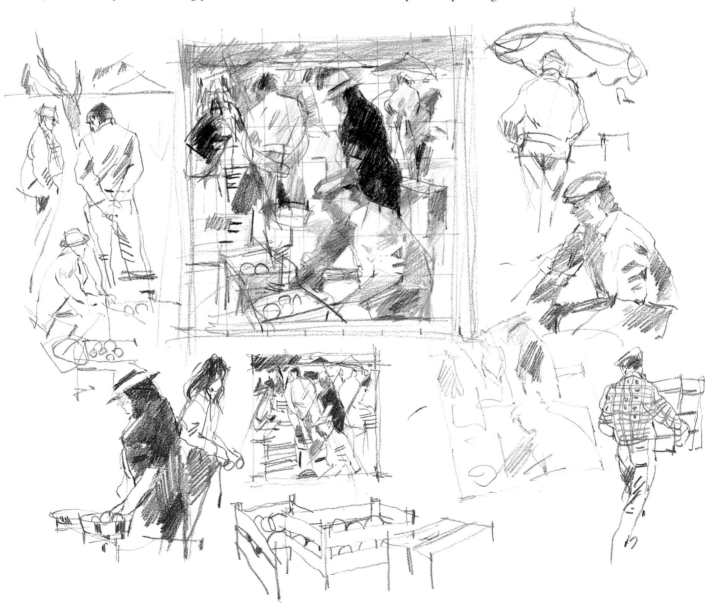

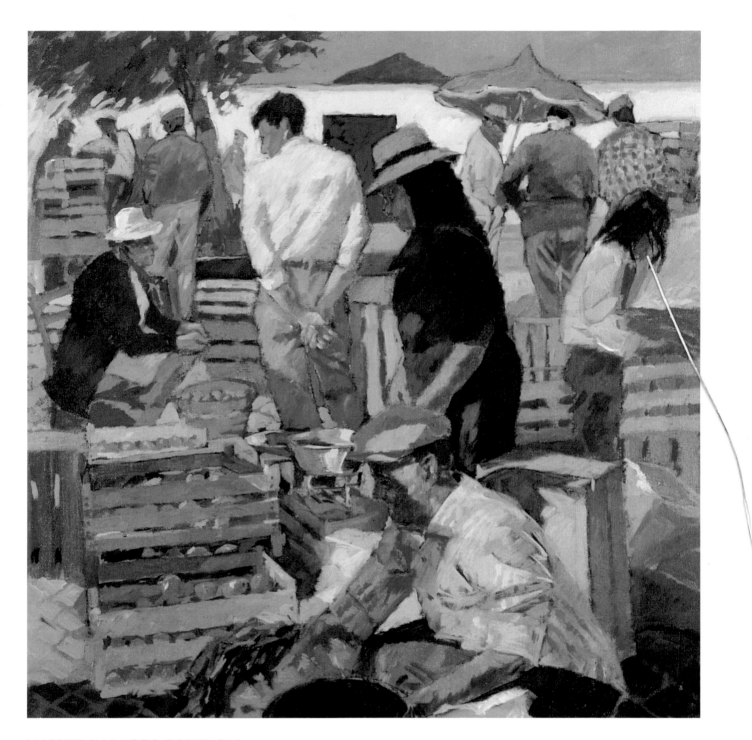

MARKET IN LAGOS, PORTUGAL
51 x 51cm (20 x 20in), acrylic and oil on linen canvas

This painting is based on the sketches opposite, plus memories of innumerable visits to Lagos market. I drew a rough grid on the sketch and then transferred the image square by square. Remember that to avoid distortion the picture must be the same shape as the original sketch. I only used the grid to plot the bare bones of the sketch, working freely to retain the immediacy of the original. I did not follow the sketch slavishly, but made additions and changes so as to produce a well-constructed composition. I blocked in the underpainting with acrylics. Because they dry quickly you can make a lot of progress in a very short time, which is helpful when

you are developing the composition. It is also easy to overpaint on acrylics and make changes. Once I was happy with the broad structure of the picture I changed over to oil paint. I find oil a more sympathetic medium than acrylic, enabling me to produce subtle gradations of tone and to modify the acrylic underpainting with delicate glazes. Another reason is that, because oil paint dries slowly I can continue to work wet-in-wet for days. Although the painting was created in the studio it captures some of the energy of the original sketch and the bustling activity of a busy market on a hot summer's day.

CHAPTER 3
ANIMALS AND BIRDS

Since the dawn of time the human race has relied on animals for food, clothing, transport, sport and companionship, and this close relationship has frequently been celebrated in art. The animal drawings in the caves at Lascaux in France that display such energy are probably more than 15,000 years old. Giorgio Vasari (1511–74) tells us that Leonardo da Vinci (1452–1519) kept horses because they 'gave him great pleasure, as indeed did all the animal creation which he treated with wonderful love and patience.' He also describes Leonardo walking through the caged bird market and buying birds in order to set them free.

We may no longer be a primarily rural population, but there are still plenty of opportunities to study animals at close quarters. The most obvious candidates are the animals we live cheek by jowl with – our cats and dogs. The advantage of pets as subjects is their availability as models. The artist David Hockney constantly draws his dachshunds, Stanley and Boogie, and, knowing that dogs are not particularly co-operative, he has drawing materials at the ready in all the rooms that they frequent – a useful tip.

There are safari parks, zoos and urban farms to visit, and every year more people travel on packaged 'safaris' to see animals in their natural habitat.

Sketching animals demands the same processes as drawing any other moving subject. You need to simplify, commit details to memory, work fast and practise. Do not judge yourself too harshly at first; simply draw what you see and you will find that the results will be pleasing.

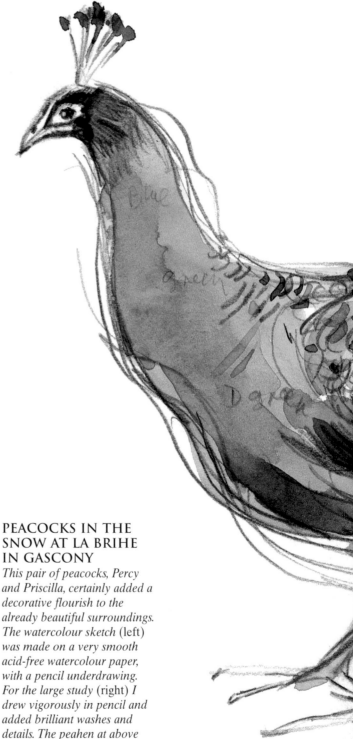

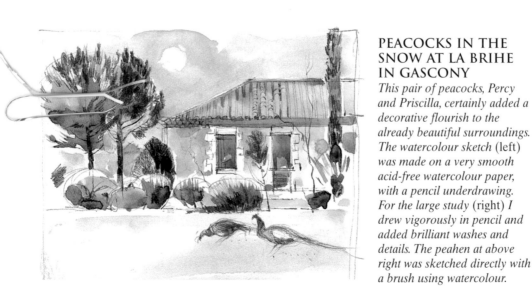

PEACOCKS IN THE SNOW AT LA BRIHE IN GASCONY
This pair of peacocks, Percy and Priscilla, certainly added a decorative flourish to the already beautiful surroundings. The watercolour sketch (left) was made on a very smooth acid-free watercolour paper, with a pencil underdrawing. For the large study (right) I drew vigorously in pencil and added brilliant washes and details. The peahen at above right was sketched directly with a brush using watercolour.

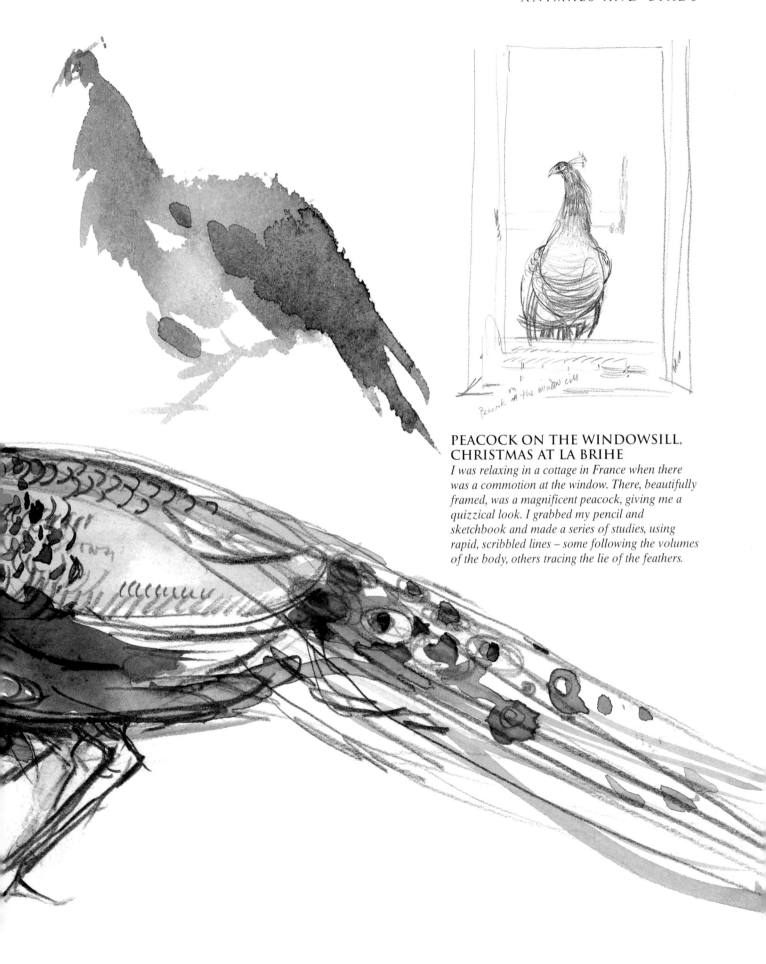

Peacock on the window sill

PEACOCK ON THE WINDOWSILL, CHRISTMAS AT LA BRIHE

I was relaxing in a cottage in France when there was a commotion at the window. There, beautifully framed, was a magnificent peacock, giving me a quizzical look. I grabbed my pencil and sketchbook and made a series of studies, using rapid, scribbled lines – some following the volumes of the body, others tracing the lie of the feathers.

CATS

Cats have been domesticated since prehistoric times and were frequently the object of veneration or superstitious fear. These days they are often our closest companions, so it is natural that we should want to draw them. The best subjects for the sketcher are always those that are readily available, because there is no excuse not to produce a image – you can just pick up your sketchpad and draw.

Cats are nocturnal animals and spend much of the daylight hours asleep, giving even the most tentative sketcher time to put something down on paper. Once you start studying cats you will notice that they actually have quite a limited range of poses that they return to time and again. So if your cat is sitting bolt upright staring at something, but moves away before you can complete your sketch, do not worry: at some point, maybe even days later, you will catch it in exactly the same pose and you will be able to pick up drawing where you left off.

The splendid cats shown here are not mine, but I have spent quite a lot of time with them. Pip and Squeak belong to some friends who live at La Brihe in France, and these sketches were made during a Christmas holiday I spent there.

Tip:
🐾 *Make a series of studies on a large page. If the cat moves, simply start another drawing; it may return to the original pose later.*

SQUEAK ON THE LOOKOUT
This quick sketch caught a fleeting pose. I used a 3B pencil, varying the pressure to achieve different qualities of line. A bit of smudging on the rump added form.

CATS ASLEEP
This somnolent pair were drawn directly using a brush and a wet-in-wet watercolour technique, with no preliminary drawing. This minimalist approach was inspired by Chinese brush drawings.

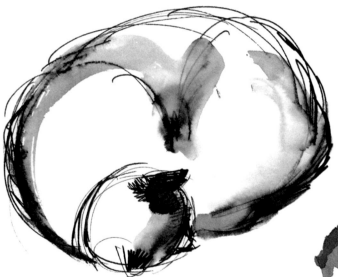

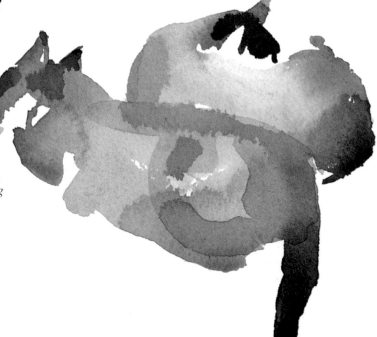

SQUEAK IN PEN AND INK (above)
Cats are incredibly flexible and often curl up into a compact ball. For this study I used a dip pen and brown ink. A series of curving lines describes the body, head and haunches, and darker tones are established with a few economical brushstrokes, giving the image a sense of bulk and volume. The dark ears and tail are characteristic of the breed.

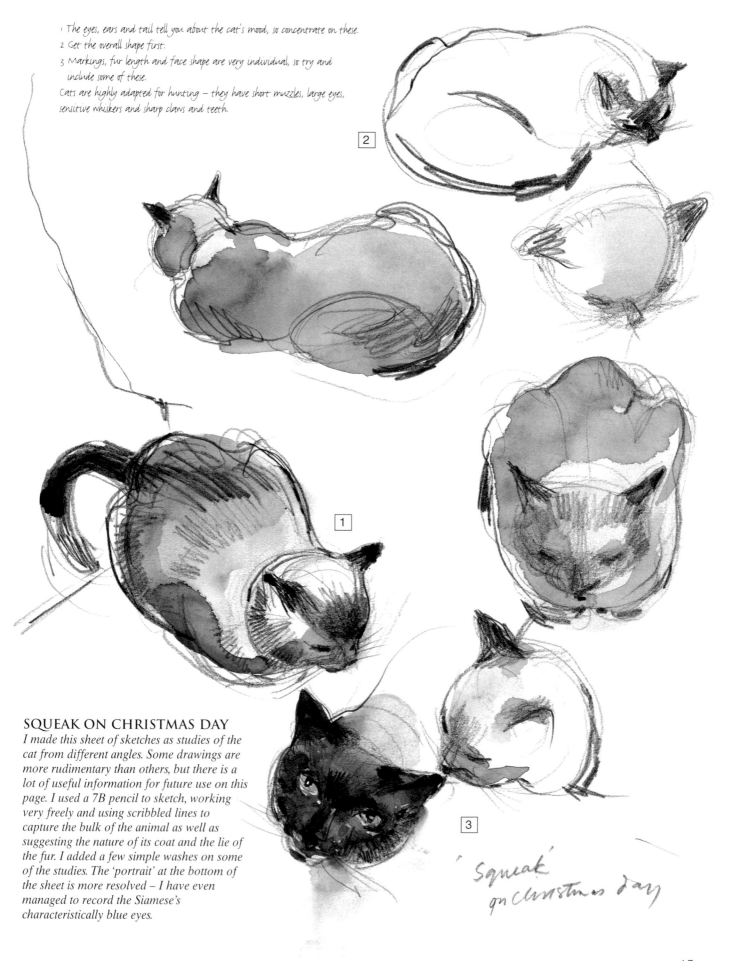

1 The eyes, ears and tail tell you about the cat's mood, so concentrate on these.
2 Get the overall shape first.
3 Markings, fur length and face shape are very individual, so try and include some of these.

Cats are highly adapted for hunting – they have short muzzles, large eyes, sensitive whiskers and sharp claws and teeth.

SQUEAK ON CHRISTMAS DAY

I made this sheet of sketches as studies of the cat from different angles. Some drawings are more rudimentary than others, but there is a lot of useful information for future use on this page. I used a 7B pencil to sketch, working very freely and using scribbled lines to capture the bulk of the animal as well as suggesting the nature of its coat and the lie of the fur. I added a few simple washes on some of the studies. The 'portrait' at the bottom of the sheet is more resolved – I have even managed to record the Siamese's characteristically blue eyes.

'Squeak' on Christmas day

Dogs

The dog has probably been domesticated for over 10,000 years. Centuries of selective breeding for special purposes – to pursue and retrieve game, to herd animals and to act as guards and companions – have led to a huge variation in body shape, size, head shape and fur length. So there is really no such animal as a typical dog. The one you know best is undoubtedly the easiest to start with; it is readily available and you should already be familiar with its appearance. With all animals it is useful to start by studying them when they are at rest; there is no point in making life difficult by taking on a moving target.

It is helpful to mentally reduce the subject to a series of simple geometric shapes, and also to try to understand what is going on beneath the surface. I have included a sketch of a dog's skeleton below, made from an exhibit in a museum. If you are interested in drawing animals you should visit a museum of natural history, and study and draw from the skeleton. Even a very rudimentary understanding of the underlying structures will help you to observe the animal differently. You will be able to make sense of what you see, and that will give you more confidence, which in turn will make your drawings less tentative. You can learn a lot by running your hand over your dog's body to feel the shape of his skull and the line of his spine.

DACHSHUNDS AT AUDLEY END

These studies of long-haired dachshunds are the result of a weekend spent with friends. I worked on a large sheet of Rough Arches watercolour paper and used a 7B pencil and watercolour washes. As with the cat studies I had to take my chance and draw the animal at its convenience, so if it moved I had to abandon the drawing and start another. Fortunately, dogs do actually hold some poses for quite considerable lengths of time. When you have drawn a snoozing dog a few times you will feel more confident about tackling the animal in motion.

TATI
This little dog was a stray adopted by my friends in France. The sketch was done in black pencil on Ingres paper, with watercolour wash added.

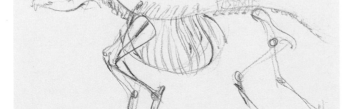

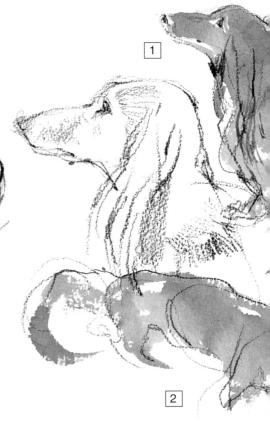

SKELETON OF A DOG

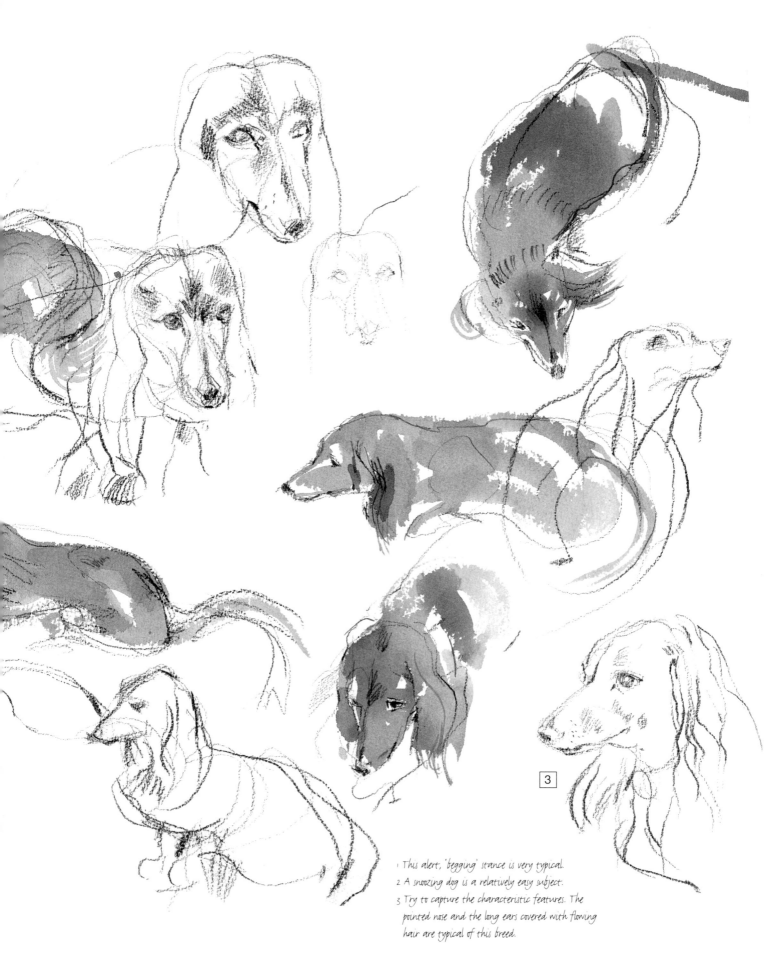

3

1 This alert, 'begging' stance is very typical.
2 A snoozing dog is a relatively easy subject.
3 Try to capture the characteristic features. The
 pointed nose and the long ears covered with flowing
 hair are typical of this breed.

SHEEP AND GOATS

You might expect to find the strangest and most exotic animals in a zoo or safari park, but what could look odder than an ordinary farm-reared sheep with its barrel-like body supported on thin, frail-looking legs? The real problem with sketching sheep is the way in which the wool conceals the underlying structures. For this reason goats, with their short hair, are much easier to understand for drawing purposes. It helps if you reduce the animal to a series of simple geometric shapes. The body of the sheep can be represented by a cylinder, with a cone for the head and neck, and tapering cylinders for the legs.

You should also look for the three places at which the body is divided: these are the shoulders, the belly and the hind quarters. These are important divisions in all animals. Try and imagine hoops encircling the animal at these points – when it is standing facing you, these hoops

appear to be closer together. These divisions are especially helpful when you are trying to understand the structure of an animal that is lying down or is curled up. They can be seen very clearly in the cat and dog studies on pages 44–5 and 46–7.

Another useful trick is to make a stick drawing of the animal, using your pencil to 'measure' the relative proportions of the body, legs and head. Hold the pencil out in front of you with your arm fully extended and lay the pencil along the relevant part. If the top of the pencil aligns with the top of the body you can mark the other end with your thumb. When the proportions are correct you can organize the volumes of the animal around this scaffolding. It can help if you imagine the drawing process as similar to the technique of modelling in clay around an armature.

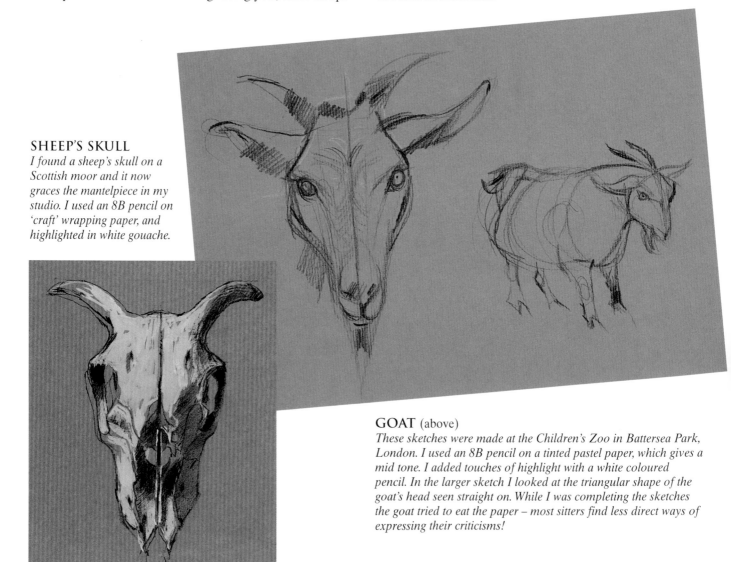

SHEEP'S SKULL
I found a sheep's skull on a Scottish moor and it now graces the mantelpiece in my studio. I used an 8B pencil on 'craft' wrapping paper, and highlighted in white gouache.

GOAT (above)
These sketches were made at the Children's Zoo in Battersea Park, London. I used an 8B pencil on a tinted pastel paper, which gives a mid tone. I added touches of highlight with a white coloured pencil. In the larger sketch I looked at the triangular shape of the goat's head seen straight on. While I was completing the sketches the goat tried to eat the paper – most sitters find less direct ways of expressing their criticisms!

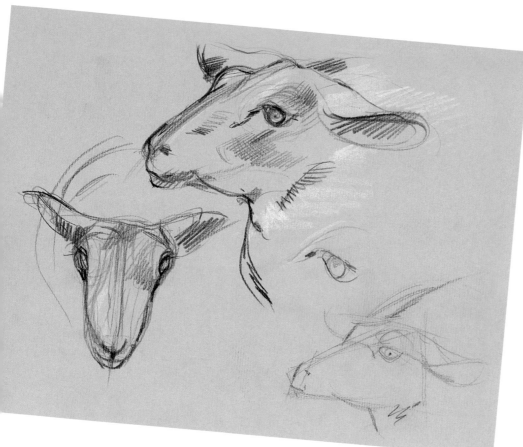

SHEEP PORTRAITS (left)

These studies were made at the same children's zoo as the goat studies. Such places provide wonderful opportunities to study animals at close quarters. The animals are used to people, so they are not shy or nervous as subjects.

GRAZING SHEEP

Sheep are terribly curious and have not been told that it is rude to stare! I made these pencil studies on a hillside near La Brihe in France. Notice the barrel-like body, the divisions at the haunches and shoulders, and the way I have used looping lines to suggest the bulk and volume of the body. Look, too, at the impossibly thin legs of the sheep.

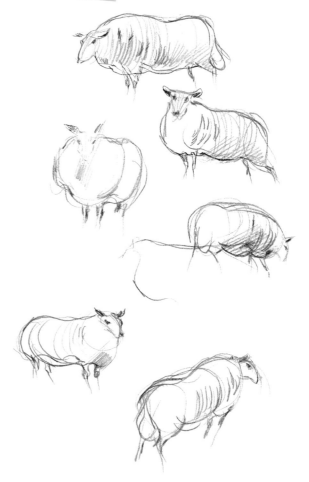

SHEEP-SHEARING

I saw a demonstration of traditional sheep-shearing methods using hand-held shears at a country fair in Cumbria, north-east England. People at work make an engrossing subject and sheep-shearers are marvellous to watch. They grab the sheep, turn it on its back and run the shears over the body in a series of economical movements that have the grace of a dance. I tried to capture the deftness and skill in my pencil sketch.

HORSES

When the photographer Eadweard Muybridge published his series photographs of a horse galloping in 1878 it was a revelation, because until that time artists had shown the galloping horse with front and back legs outstretched like a rocking horse. According to Muybridge there is no point at which all four feet are off the ground; in fact there is, and George Stubbs (1724–1806), acknowledged to be one of the greatest painters of horses, had painted them in this way. This just goes to show that you cannot always believe the evidence of your own eyes, and it also illustrates the extent to which you really see what think you know and understand – it can be a trap as well as an advantage. So, for example, it is worth visiting natural history museums or looking at books on animal anatomy to see the underlying skeleton, but when you are sketching from life you must draw what you observe, even if it looks odd. Nevertheless, what you have learned from study and observation will inevitably inform your drawing.

HORSE SKELETON
This study was made in a natural history museum. The associated diagram serves to highlight the key joints and their movements.

DRESSAGE
These tiny studies of horses being put through their paces at a dressage event were preparation for a commission. I used pencil on Ingres paper.

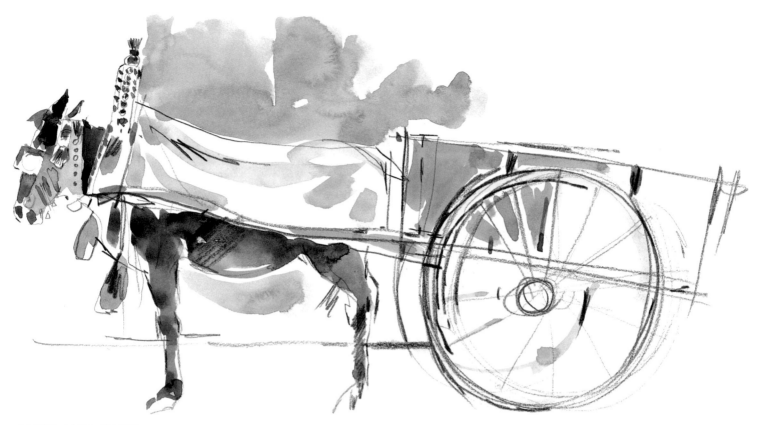

MULE AND CART
This mule with its colourful cart and panoply were standing quietly on a side street in Lagos, Portugal, on market day. With this sort of subject it is important to draw the mule and the cart as a single element, getting the relationships correct. I used a combination of pencil and watercolour.

PAGEANT, 1948 (below)
I made this charcoal study when I was a very young man. The occasion was a pageant in St Albans, Hertfordshire, England, and the animal was richly caparisoned for the event. Charcoal is a friable material, but the drawing was fixed and protected within the pages of the sketchbook, so the image has survived the passage of time remarkably well.

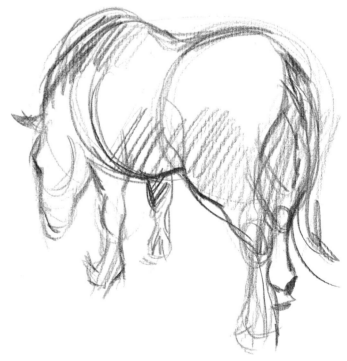

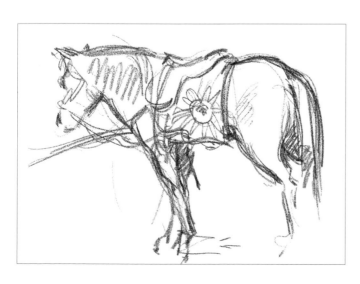

GRAZING PONY
This solid little pony lived in the Children's Zoo in Battersea Park, London. Notice the barrel-like body, the bulky haunches, the obvious divisions at shoulder and haunches, and the way the body is telescoped because the animal is turned away from us.

ZOO ANIMALS

A good way of improving your powers of observation is to spend a day at the zoo. The material is so rich and varied that you will feel compelled to pick up your pencil and sketch. You will be able to study animals from close quarters as they eat, sleep, prowl around, work with their keepers, or tumble about with others of their kind.

Allow yourself plenty of time and start by watching the animals carefully before deciding on your subject. A sleeping lion or leopard is a relatively uncomplicated subject, for instance, but a compound full of scampering monkeys is altogether more challenging. Start with an easy subject, such as an elephant which tends to move slowly, or a big cat taking a catnap. Look for the simple shapes underlying the form, and try and imagine the hidden skeleton and muscle groups. When you have sketched the main shapes, add the most characteristic surface details, such as the leopard's spots or the crinkles and wrinkles on an elephant's hide.

When you have got your hand and eye in you can tackle less static subjects such as monkeys, penguins or tropical birds.

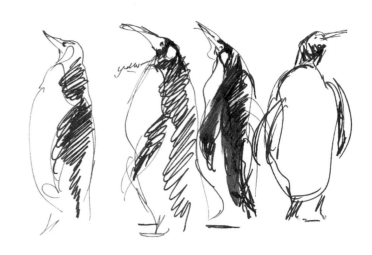

PENGUINS
Everyone loves penguins – they bustle about like a crowd of old gentlemen all dressed up in their best bib and tucker. I used a fountain pen on a smooth paper for the sketch. The pen skimmed over the paper to give an uninterrupted, flowing line for the main outlines, and then I used scribbled hatching and more solid tones for the birds' black feathers.

CHEETAH
This athletic cheetah was sketched at Whipsnade Zoo, Bedfordshire, England. I used fountain pen for the main outlines, then I drew the dots and circles on its dappled skin. I smudged the wet ink with my finger – you can actually see my fingerprints. When the ink was dry I used a coloured pencil to scribble on the tawny colour of the animal's skin.

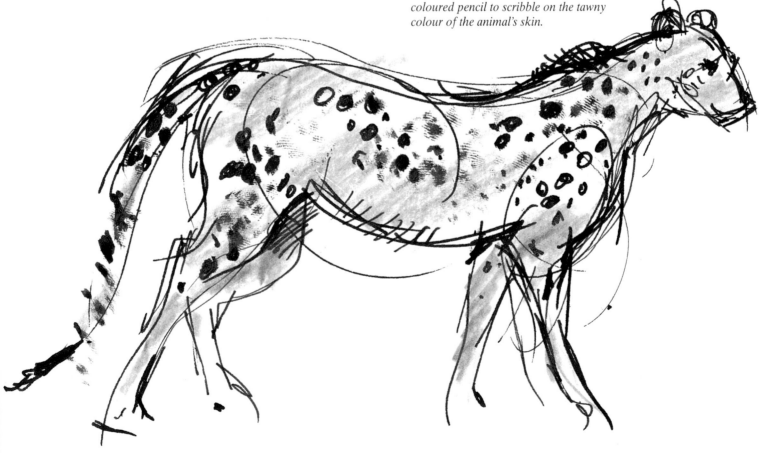

ELEPHANT (right)

For this elephant study I used charcoal on a smooth paper. I worked quickly to establish the main outline, with a few lines to suggest the creases in the animal's trunk and the wrinkles on its hide. I did not want to build up the charcoal too much because the paper did not have much tooth and charcoal smudges easily. I fixed the drawing with spray fixative when I returned to the studio.

ELEPHANTS

These elephant studies were made with fountain pen on Rough watercolour paper. I added soft pastel to the most finished drawing – notice how the colour has broken over the textured surface of the paper, suggesting the roughness of the elephant's hide. The figure glimpsed between the animal's legs is actually giving the elephant beyond a pedicure. The keepers train the animals to lift their feet and lie down to order so that these delicate, but important, tasks can be performed regularly and easily. And, of course, they make fascinating pictures!

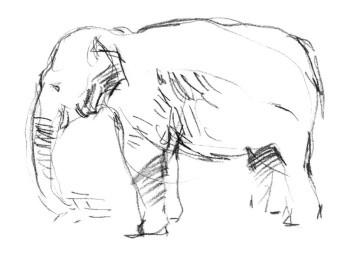

Tip:

🐾 In an emergency you can use hairspray to fix a charcoal or pastel drawing.

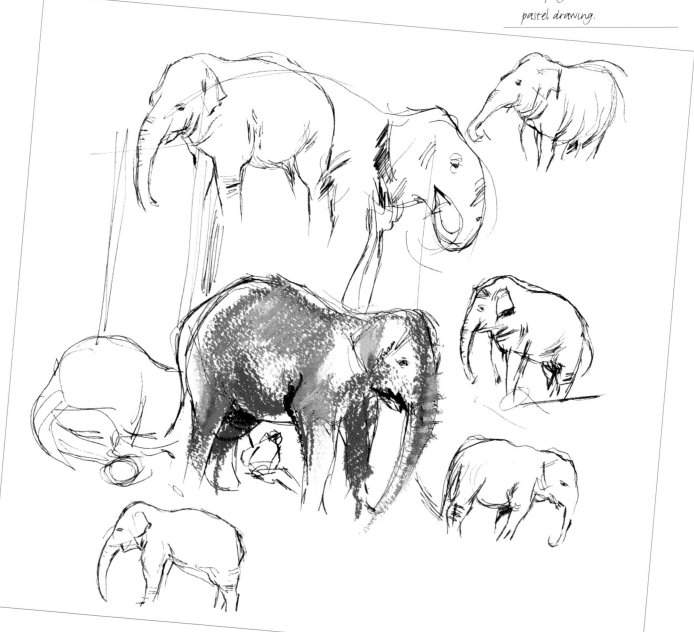

53

MORE ZOO ANIMALS

All the sketches on these pages were made at London Zoo. I like drawing exotic animals from time to time because they are full of surprises, and the sheer variety of their forms forces me to really look at the subject – and that keeps my drawing fresh and my observation sharp.

CAMEL
The camel was drawn using a Mont Blanc fountain pen and watersoluble writing ink. I applied some water with a brush to create a tone, and the black writing ink separated out into its constituent parts, creating subtle tones that are entirely appropriate for the subject – an example of a 'happy accident'.

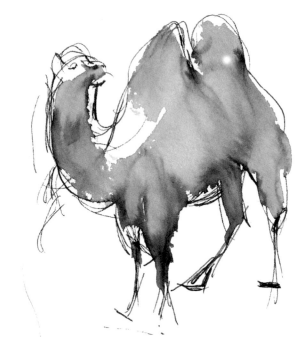

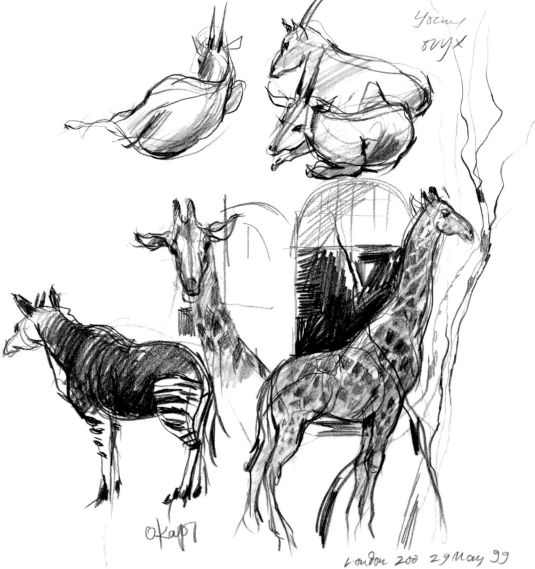

ORYX, OKAPI AND GIRAFFE (left)
On this sheet I used a combination of black pencil and coloured conté pencils. The markings on the okapi and giraffe are particularly eye-catching and I spent some time on these details. I smudged the conté pencil on the giraffe to achieve a generalized background tone. I am rather pleased with the 'portrait' study of the giraffe in the centre – and the animal was very aware of being admired, too!

ARABIAN ORYX
These oryx were rather appealing to draw as they simply munched away and did not move much. Their horns were spectacular. I used a combination of black pencil and a dark orange conté pencil. These animals have slender legs, rather bony haunches and shoulders, and a pot belly – you can see this clearly in the top central drawing. Notice that I have indicated the location of the spine in the recumbent animal at the bottom of the page.

54

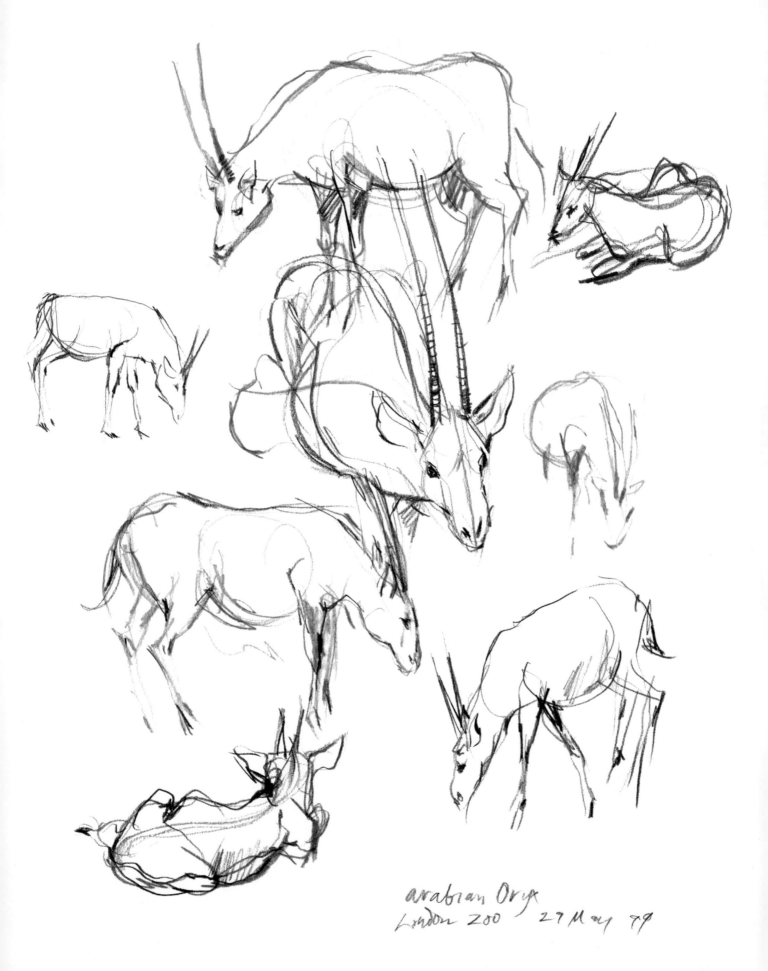

arabian Oryx
London Zoo 27 May 79

WILD BIRDS AND DOMESTIC FOWL

When you are drawing birds, look for the features that distinguish one species from another, such as a characteristic body shape, the length of the legs and the shape of the bill. Wings may be slim and pointed, short and blunt, or wide and deep. Tails, too, vary in shape; some are deep and forked, while others are short and blunt. Identify and simplify these shapes, and then look for the bird's characteristic stance, the angle of the body and the tilt of the head. When birds are in flight the best policy is to concentrate on the silhouette.

I use a large sketchbook and cover the page with studies. Birds tend to dart about, adopting all sorts of different attitudes and then fluttering off to a different spot, so some drawings will be incomplete. Sometimes another bird will adopt the same pose, however, and thus allow you to finish a drawing later.

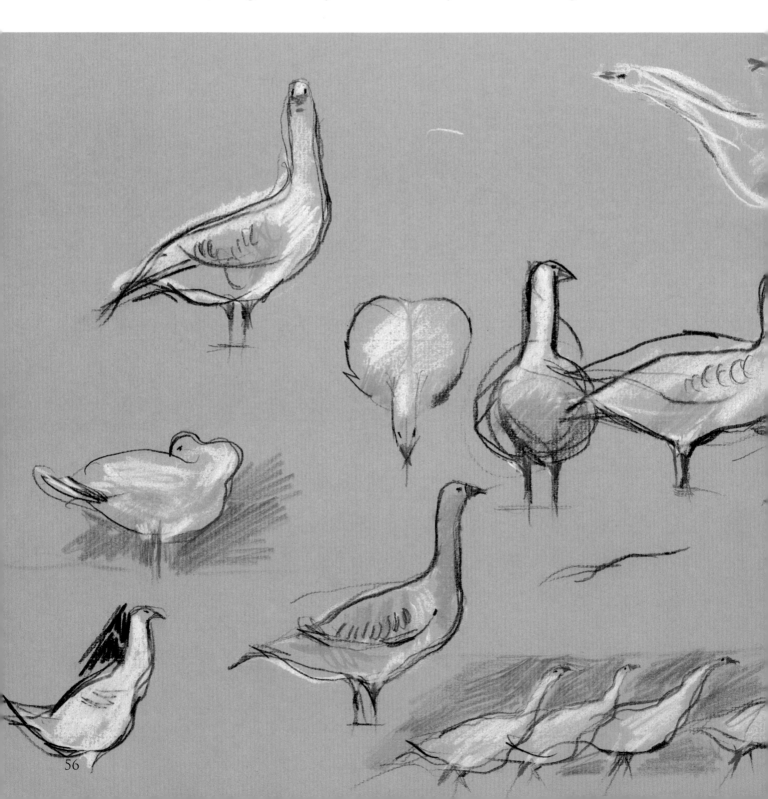

ROOKS AND MAGPIES

I found this mixed flock of birds feeding in a London park. They were fascinating as they scurried about, heads down pecking for food, standing alert head on one side, then fluttering off to another spot a few metres away. I used a fountain pen on Ingres paper, concentrating on stance, shape and the type of flight movements.

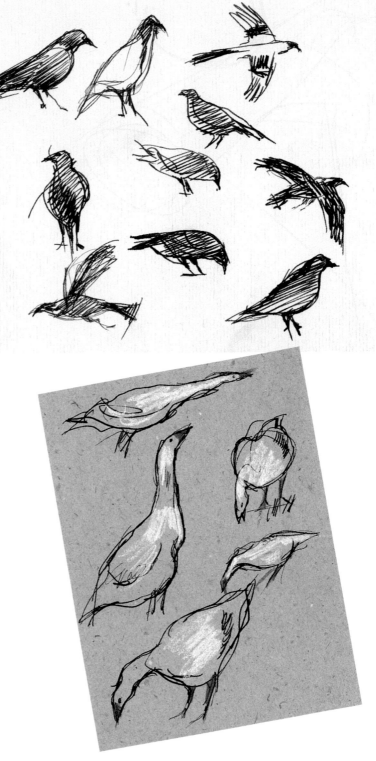

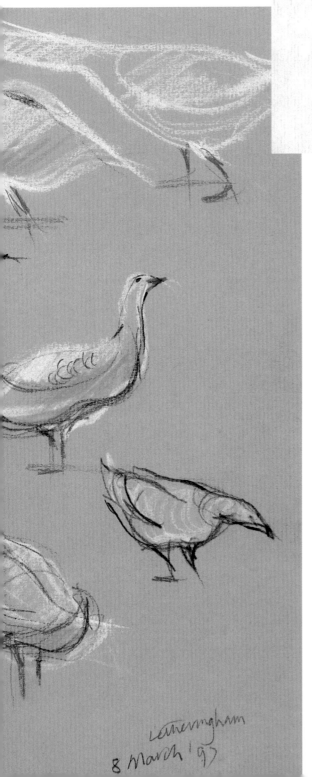

GEESE AT LETHERINGHAM

Geese make relatively easy subjects because they are big, fearless and tend to stay still for minutes at a time. For the sketches above I worked on a pad of recycled paper that was a warm oatmeal colour and had an interesting flecked texture. I used fountain pen with white conté highlights. The large sheet of studies was made on Ingres pastel paper using an 8B pencil and coloured pencils.

57

MORE BIRDS AND FOWL

Birds actually have the same basic structure as other vertebrates, but their adaptations for flight, their thick covering of feathers, and the enormous range of colour, pattern and form make them especially rewarding subjects to study. Beak shape can vary from the sharp, curved bills of birds of prey to the long, spear-like bills of fish-eaters such as kingfishers. Birds that require an all-round field of vision to avoid predators have their eyes set at the sides of their head, while birds that hunt, such as owls, have their eyes set to the front of the head so they can focus with pinpoint accuracy on their prey.

Although they are seen at their best in the wild, birds in captivity offer a wonderful opportunity for close study. Make careful and detailed drawings, as well as quick sketches noting proportions, angles and balance. These studies will give you the knowledge and confidence to tackle the bird on the wing.

Wing shape, wing movement and the overall silhouette are unique to each species. You will find that birds that spend a lot of time in the air have long wings and lighter breast muscles, and tend to glide much of the time, using the thermals and a slow leisurely wing motion to stay aloft. At the other extreme are the birds that hover. With these, the body is tilted slightly upward and the wings flap back and forth at a rapid rate, creating a very different profile. Then there are the birds of prey which hover and then plummet towards their prey, with wings pointing back to give them the aerodynamics of a dart. If you analyse, compare and sketch, your knowledge and your skills will improve in tandem.

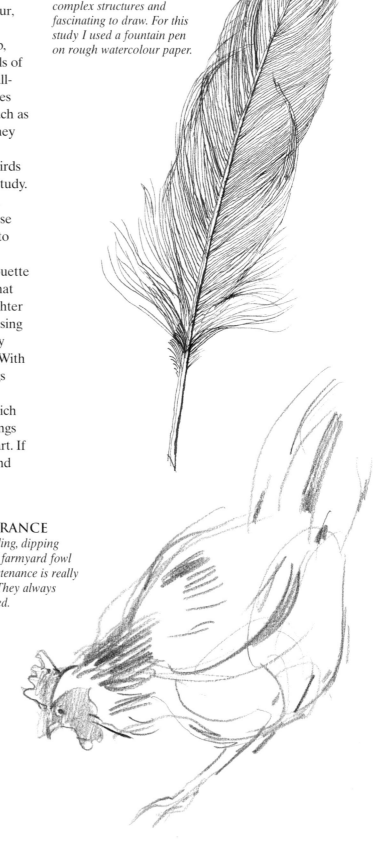

A GOOSE FEATHER
Feathers are beautiful and complex structures and fascinating to draw. For this study I used a fountain pen on rough watercolour paper.

HENS IN FRANCE
The fussy scuttling, dipping and pecking of farmyard fowl in search of sustenance is really very amusing. They always look so bothered.

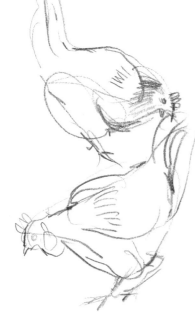

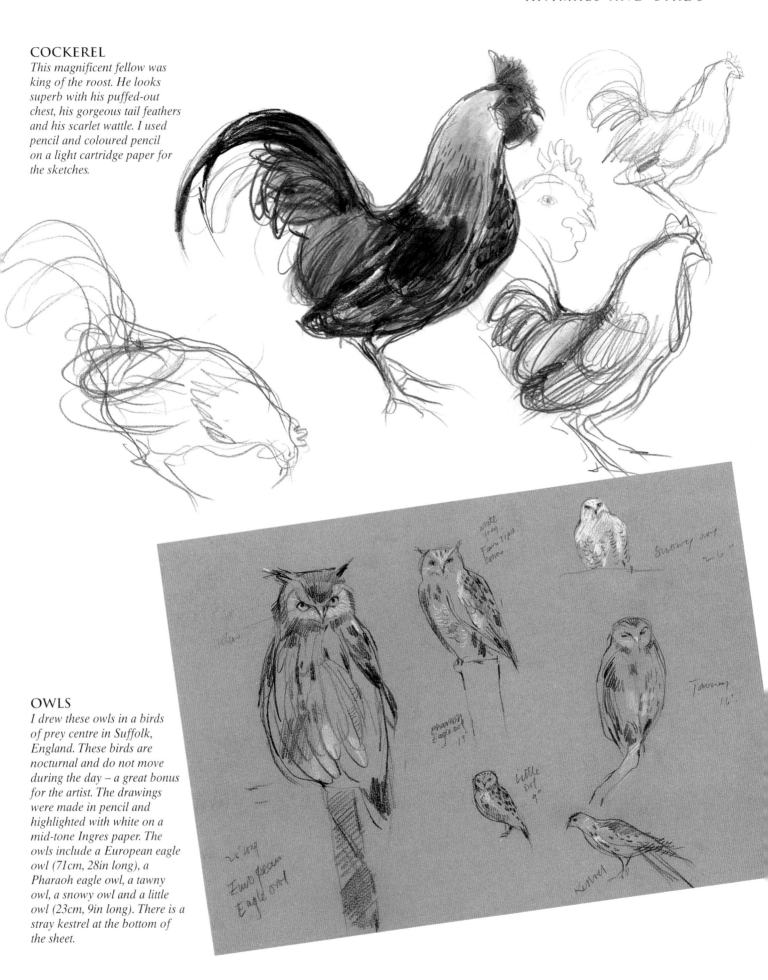

COCKEREL

This magnificent fellow was king of the roost. He looks superb with his puffed-out chest, his gorgeous tail feathers and his scarlet wattle. I used pencil and coloured pencil on a light cartridge paper for the sketches.

OWLS

I drew these owls in a birds of prey centre in Suffolk, England. These birds are nocturnal and do not move during the day – a great bonus for the artist. The drawings were made in pencil and highlighted with white on a mid-tone Ingres paper. The owls include a European eagle owl (71cm, 28in long), a Pharaoh eagle owl, a tawny owl, a snowy owl and a little owl (23cm, 9in long). There is a stray kestrel at the bottom of the sheet.

FROM SKETCH TO FINISHED PAINTING: BONNY AND CALAMITY

This pair of aristocratic Siamese cats live in La Brihe, in Gascony, France. Cats are wonderfully languid and self-absorbed creatures, entirely sure of their place in the universe, and I love to watch and sketch them. I particularly liked this study of Bonny and Calamity curled up together, and thought it might make a good painting.

The original sketch was made in pencil with watercolour washes. I was deliberately looking for a composition that would work as a picture rather than simply another cat study, so background elements such as the chair and the cushion are important. Making a sketch is a bit like thinking out loud – it helps you clarify your thoughts. You will also find that different sketches have different intentions – some are made so as to gather information, while others are to explore an idea. The sketches of these cats fall into the latter category.

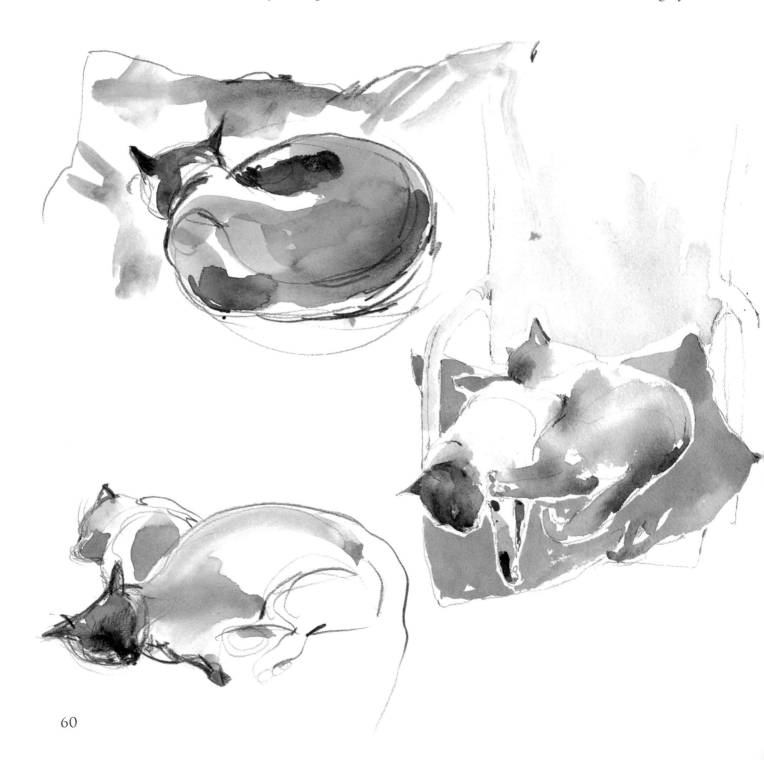

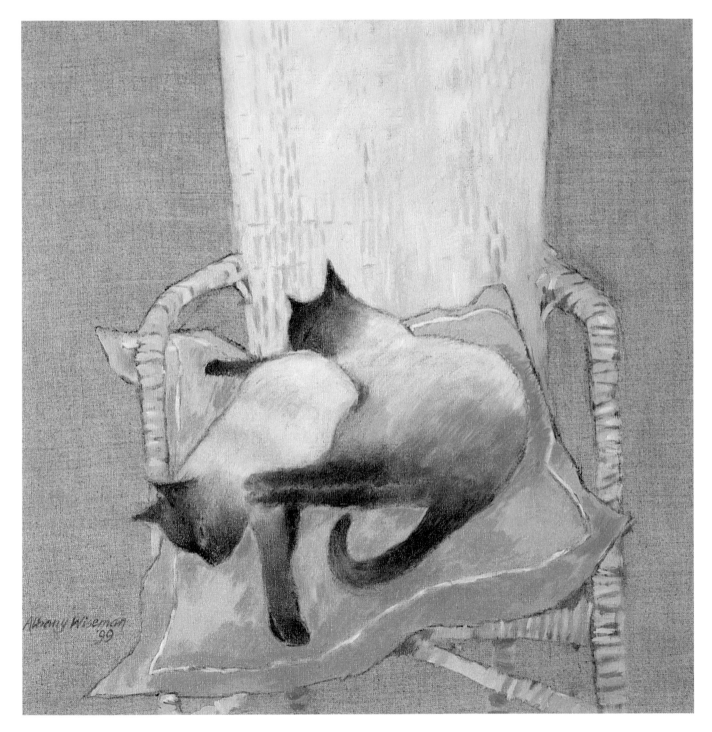

BONNY AND CALAMITY AT LA BRIHE
46 x 46cm (18 x 18in), oil on linen canvas

The support for this painting is stretched linen sealed with an acrylic canvas sealer, which is invisible when dry. This allowed me to retain and exploit the colour and texture of the fabric. I like this support because it provides a mid tone to work against. As soon as you add dark tones and light tones an image emerges very quickly. It is much easier than working on a brilliant white support.

I did not scale up the original sketch, but drew directly on to the support using charcoal and then just made some adjustments in order to create a tighter, more dramatic composition.

I worked with a very limited palette, so the painting has a restrained, tawny look that seems to suit the subject. I applied the paint rather loosely, and in places, large passages of the linen canvas are incorporated into the image. I used a mix of raw sienna and Naples yellow for the chair, while the bright pink cushion is mixed from a colour called 'ruby lake light' with white. The cats' warm chocolate brown fur is mixed from burnt umber and black.

CHAPTER 4
THE INTERIOR

The interior of your home can provide a rich source of inspiration and should not be overlooked for potential subject matter. For the non-professional artist the best subject is whatever you are most likely to paint, and that is usually what you enjoy most and have easy access to. The interior, especially the domestic interior, is literally 'on your doorstep' and provides an endless choice of themes and approaches, with its variety of linked spaces, architectural features, interesting vistas and a rich tapestry of colour and texture.

Themes range from ready-made still-life groups – flowers and knick-knacks on a mantelpiece, for example – to views of rooms, peopled or empty, and vistas glimpsed through an open door or window, down a hallway or up a staircase. The uninhabited interior is a particularly evocative subject, because the presence of the absent inhabitants is always implicit. On the other hand, the occupied interior space is also an endlessly fascinating and provoking theme. Sometimes the figures are deliberately arranged as in a 'conversation piece', sometimes their presence seems merely accidental.

Before the advent of photography, painting offered the only means of recording the appearance of people and things. In the eighteenth and nineteenth centuries 'accomplished' young 'ladies' painted their homes in watercolour – some of their sketchbooks have survived, and they give us a fascinating glimpse into the homes of the period.

LILIES
These magnificent lilies were on a windowsill in France. I made a quick sketch with watercolour and a brush, working directly wet-in-wet at first, then adding a few telling details wet-on-dry with the tip of the brush.

VIEW THROUGH A WINDOW
Looking from one space to another is full of compositional potential, and windows and doors with their framed views are particularly appealing. Here, a still-life group in a cool and shadow-filled interior leads the eye to the sunny landscape beyond. I sketched in a few preliminary lines with pencil, but then worked directly with watercolour washes applied very loosely.

THE LIVING ROOM AT LES BASSACS (right)
This watercolour study was made in the cool of the living room of an old French farmhouse, on a very hot day. I worked directly with broad washes applied to a Rough watercolour paper. The interior space is handled freely, while I used a more controlled technique for the hot, sun-filled courtyard. The foliage hanging down in front of the window is seen as dark against the sunlight and is carefully rendered.

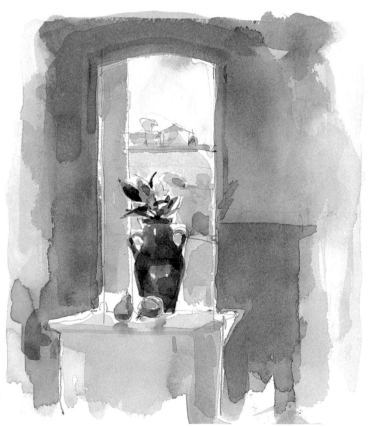

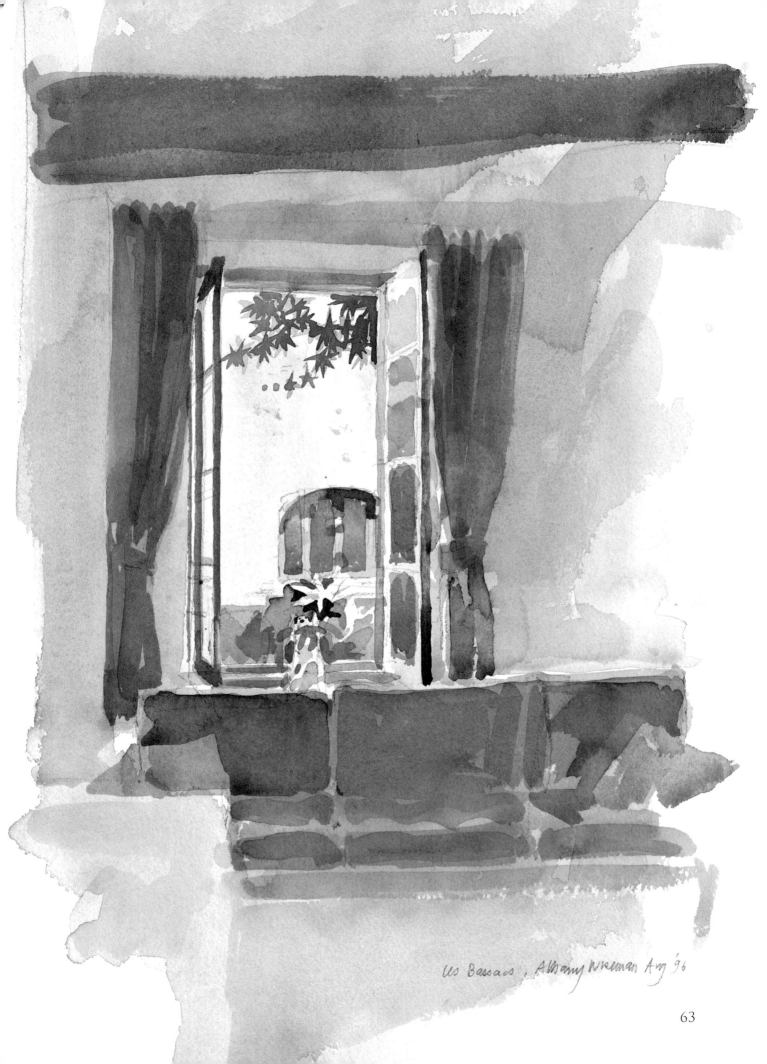

Us Bassacs, Albany Wiseman Aug '96

FLOWERS

Flowers are an absorbing and infinitely varied subject for the sketcher, but their complexity can be daunting. So if you have cut flowers or potted plants around the house, take every opportunity to draw them – the exercise will test and improve your drawing skills. Because flowers are so beautiful, beginners often concentrate on decorative aspects such as colour and pattern, and forget about structure and form. Flowers are often extremely complex forms but, like any other subject, they can be reduced to simple geometric shapes. This makes it much easier to understand their three-dimensional forms and how they might appear in perspective, and that in turn makes them much easier to draw.

Foliage is also important when sketching flowers. Study the shapes of the leaves and notice the way they grow from the stem. Some leaves grow on short stalks, while others are much longer; some emerge in pairs, others alternate or spiral up the stem. Your sketchbook is an excellent place to make detailed studies of the various elements. Once you start looking in this analytical way you will be amazed by the diversity of forms and growth patterns.

When you are sketching a plant or a bunch of cut flowers you need to combine an understanding of structure and attention to detail with a more general approach. If you draw every leaf with great precision the drawing will lose any sense of spontaneity. Use a shorthand for the leaf forms, rendering just one or two more accurately, and you will find that the eye completes the picture.

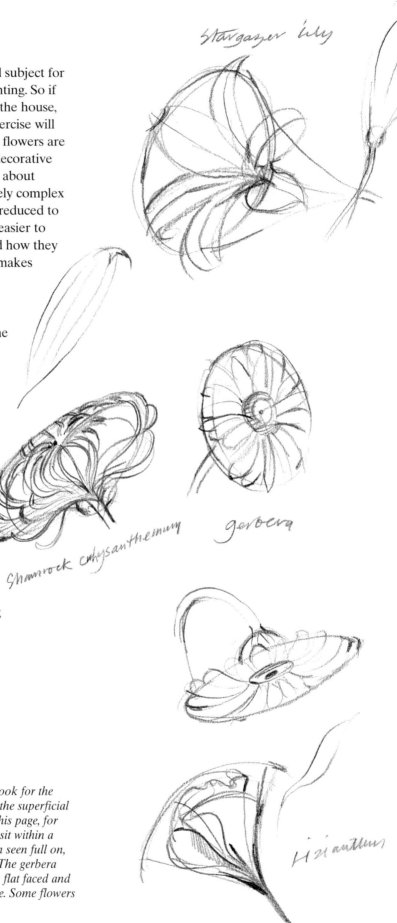

THE GEOMETRY OF FLOWERS
You will find it much easier to draw flowers if you look for the geometric shapes that provide the underpinning for the superficial forms. The flower of the stargazer lily at the top of this page, for instance, is basically a trumpet shape. The six petals sit within a cone, with the tips of the petals making a circle when seen full on, which becomes an ellipse when seen in perspective. The gerbera and shamrock chrysanthemum flowers are basically flat faced and circular, but become ellipses when turned at an angle. Some flowers may be a combination of different shapes.

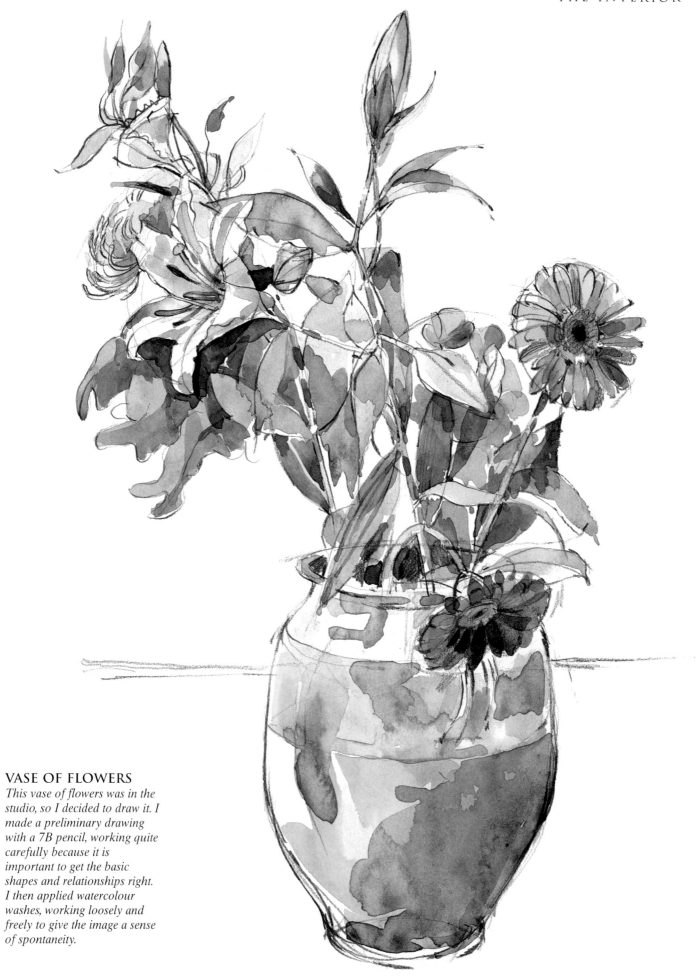

VASE OF FLOWERS

This vase of flowers was in the studio, so I decided to draw it. I made a preliminary drawing with a 7B pencil, working quite carefully because it is important to get the basic shapes and relationships right. I then applied watercolour washes, working loosely and freely to give the image a sense of spontaneity.

INTERIOR SPACES

A painting or drawing of an interior space legitimizes our natural inquisitiveness. Most people enjoy those domestic scenes glimpsed through illuminated windows after nightfall, before the curtains are drawn, but our enjoyment is tempered by a residual guilt about being caught out prying. All paintings of private interiors have that tantalizing quality.

In the search for the grand subject many artists overlook the rich domestic themes that surround them. Many artists see their own room as a sanctuary, and a sense of peace, quiet and stillness is often present in these very personal studies. Van Gogh (1853–90), writing to his brother Theo from Arles in October 1888, talked about a painting of his bedroom:

This time it's just simply my bedroom, only here colour is to do everything, and giving by its simplification a grander style to things, is to be suggestive here of rest or of sleep in general. In a word, to look at the picture ought to rest the brain or rather the imagination.

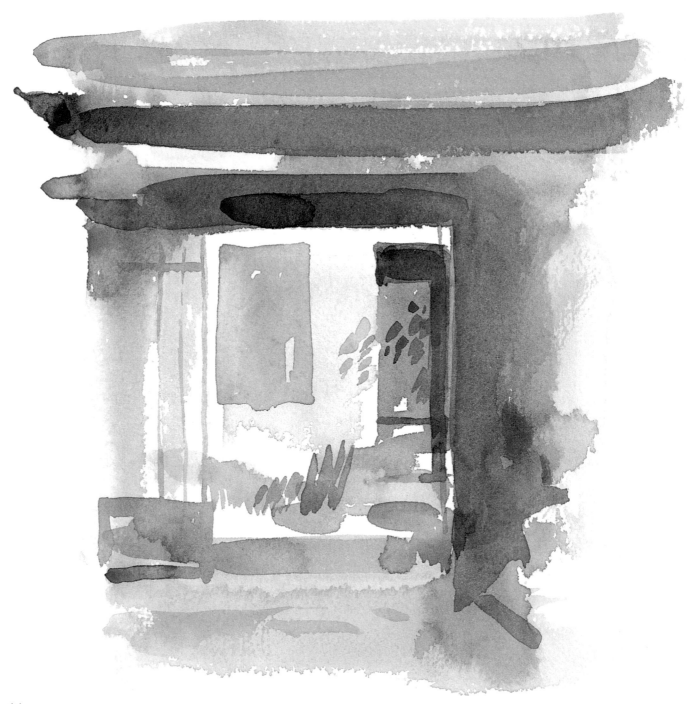

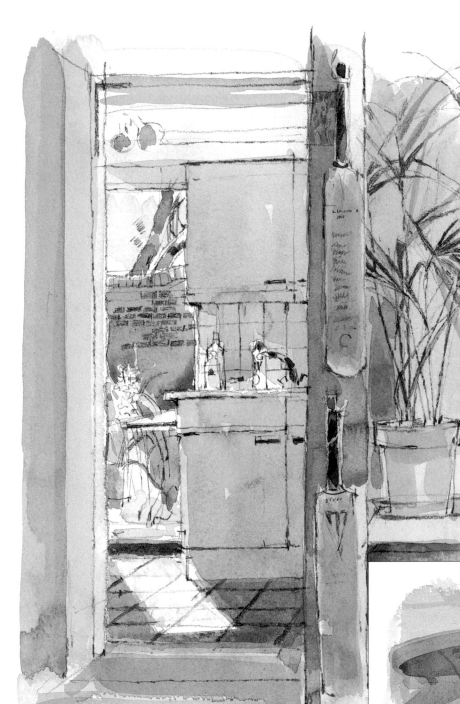

THROUGH THE DOORWAY

This is the view from my studio, through the kitchen and into the courtyard beyond. The scene is obviously familiar to me – I have worked in the studio for 18 years – but it is surprising how the everyday becomes when you take the time to really look. I sketched with an 8B pencil, then laid a cool blue-grey wash to suggest the shadows within. This suggests very successfully the sunlight outside.

OIL VATS IN SPAIN

I made this monochrome study in the cool vaults where the olive oil was once stored in these enormous clay vats. The repetition of the shapes is a strong compositional theme, which is reinforced by the unity of colour. The image was constructed from a series of simple washes, with some initial pencil lines to establish the location and size of the main vats. A few doves had flown in from the yard, and their crisp white shapes draw the eye into the image.

LOOKING FROM THE DINING ROOM, LES BASSACS (left)

This bold but simple watercolour was made in the dining room of a friend's house in France. From the cool interior of the ancient farmhouse we can see through to the courtyard and the house beyond. The watercolour is so simple that it hovers on the cusp of abstraction. Nevertheless, I like the sense of cool seclusion contrasted with the brilliance and heat beyond.

DOMESTIC STILL LIFES

For the artist, fruit, flowers, bowls, everyday domestic objects and kitchen utensils are interesting not for what they do or what they are, but for their varied shapes, colours and textures. In that sense still lifes are abstract.

A still life is generally small in scale, so you can work from close to, and really investigate the subject. The items are readily available, and any collection of household objects can constitute a still life. There is plenty of scope for actually arranging the subject to make a composition, though often random gatherings of household objects, or organized displays – on a

mantelpiece, for instance – provide themselves as ready-mades. You can also control the lighting and choose the viewpoint that offers most interest. Still lifes make less demands than people or animals, and you can work in the comfort of your own home.

Before you start sketching your still life, spend time walking around it. Notice how the composition changes when you see it from above or from straight on. Make rapid thumbnail sketches before you start your main drawing. Still life is a rich, rewarding and convenient subject for the artist, so do not neglect it.

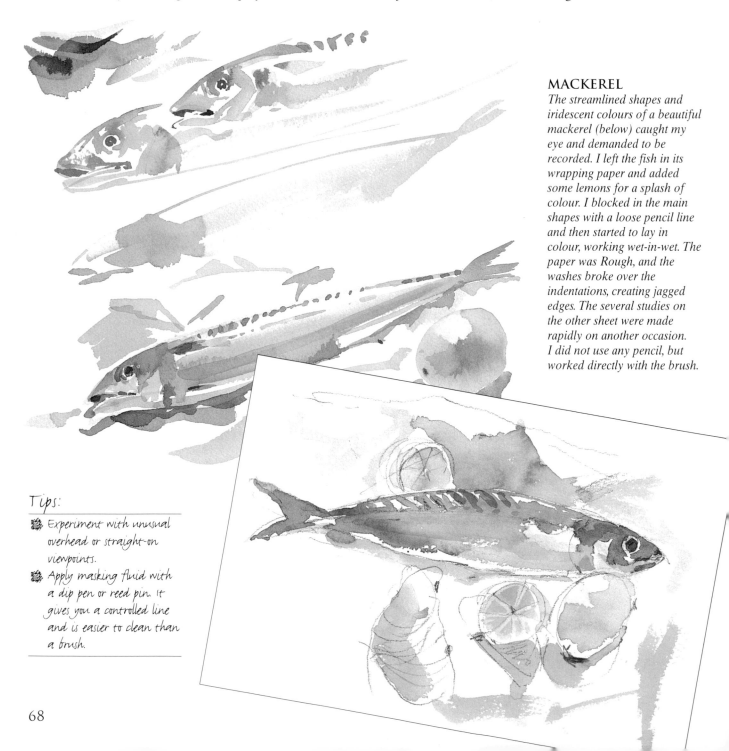

MACKEREL
The streamlined shapes and iridescent colours of a beautiful mackerel (below) caught my eye and demanded to be recorded. I left the fish in its wrapping paper and added some lemons for a splash of colour. I blocked in the main shapes with a loose pencil line and then started to lay in colour, working wet-in-wet. The paper was Rough, and the washes broke over the indentations, creating jagged edges. The several studies on the other sheet were made rapidly on another occasion. I did not use any pencil, but worked directly with the brush.

Tips:
- Experiment with unusual overhead or straight-on viewpoints.
- Apply masking fluid with a dip pen or reed pen. It gives you a controlled line and is easier to clean than a brush.

BASKET AND FRUIT
This watercolour sketch was made on a smooth H.P. watercolour paper. The smooth surface gives a special character to a watercolour; because the paper is less absorbent the paint tends to sit on the surface and puddles, drying with hard edges.

FRUIT AND GRASSES (below)
I set up this arrangement of rumpled cloths, fruit, pots and grasses on a table in my studio. The initial drawing was very simple, and put down in seconds. I used a reed pen to apply masking fluid for the delicate forms of the grasses, and allowed it to dry. I then worked very freely in watercolour. Masking the grasses allowed me to apply the dark background colour with great freedom.

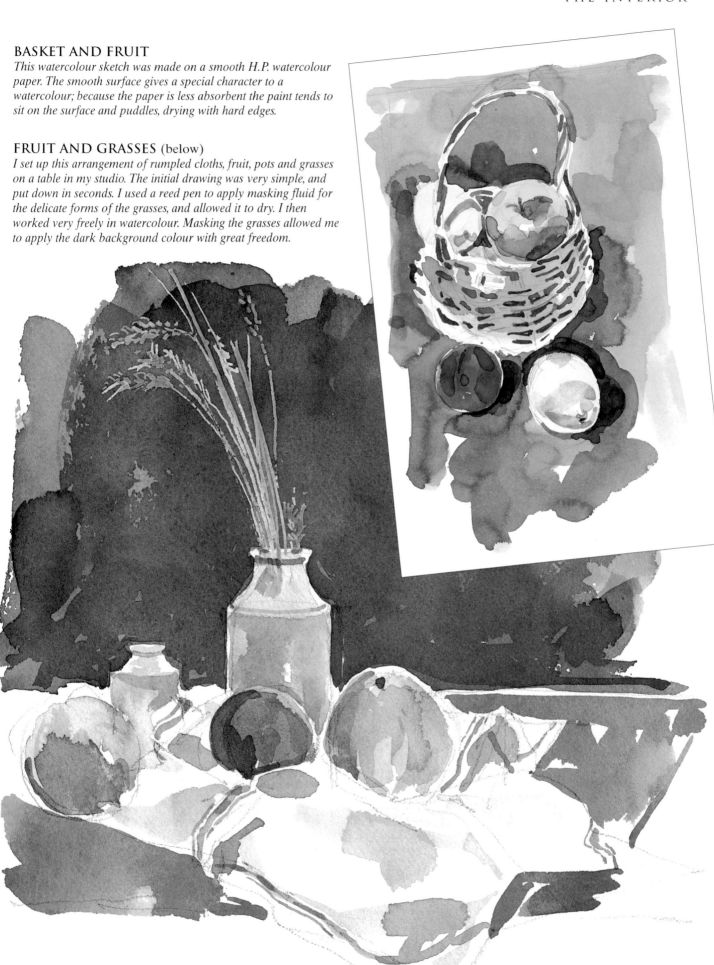

BASIC SHAPES

May I repeat what I told you here: treat nature by the
cylinder, the sphere, the cone, everything in proper
perspective so that each side of an object or plane is
directed towards a central point.
(PAUL CÉZANNE: LETTER TO EMILE BERNARD, AIX, 15 APRIL 1904)

Starting to sketch a still-life composition can be daunting;
you have to decide what to put in, what to leave out
and where to begin. Sometimes the whole arrangement
may seem so confusing that you almost feel like giving
up in exasperation. However, if you borrow the system
advocated by the great French artist Paul Cézanne
(1839–1906) you will find it much easier to start.

Look very carefully at the subject and see if you can

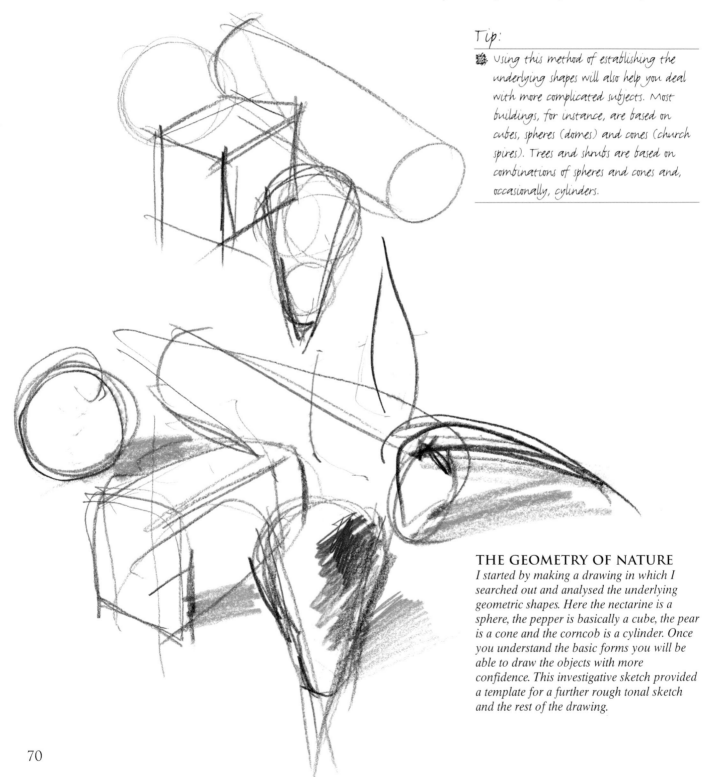

> **Tip:**
> ✿ Using this method of establishing the
> underlying shapes will also help you deal
> with more complicated subjects. Most
> buildings, for instance, are based on
> cubes, spheres (domes) and cones (church
> spires). Trees and shrubs are based on
> combinations of spheres and cones and,
> occasionally, cylinders.

THE GEOMETRY OF NATURE
I started by making a drawing in which I
searched out and analysed the underlying
geometric shapes. Here the nectarine is a
sphere, the pepper is basically a cube, the pear
is a cone and the corncob is a cylinder. Once
you understand the basic forms you will be
able to draw the objects with more
confidence. This investigative sketch provided
a template for a further rough tonal sketch
and the rest of the drawing.

reduce it to a series of geometric shapes. Cézanne recommended the cylinder, sphere and cone, but you may find that other simple shapes, such as the cube, are also useful. Make a quick drawing based on these shapes; this will give you a scaffolding upon which to hang the details of a subject.

Since these shapes are simple and familiar you already understand their structure and volumes, and it is easy to visualize them tilted, overlapping each other or in perspective. By using these forms as a basis for a drawing you can then apply your understanding of them to objects that are superficially more complex.

Your sketchbook is an ideal place to practise seeing and sketching the simple shapes underlying even the most apparently complicated forms. Start with obviously spherical, cylindrical, cone-shaped or cuboid objects.

FRUIT AND VEGETABLES

For this drawing I used a size 23 x 30cm (9 x 12in) acid-free cartridge sketchbook in ivory, a Mars Lumograph 8B pencil and coloured pencils. I built up the colour and tone using a web of loosely hatched strokes. The simple shapes shown in the sketch opposite provided a useful underpinning for the drawing, which is solidly three-dimensional and convincing. The unique characteristics of each object have been applied over these basic forms: the bundled sausage shapes of the pepper, the peeled-back leaves and the pearl-like grains of the corn, and the richly mottled surface of the pear.

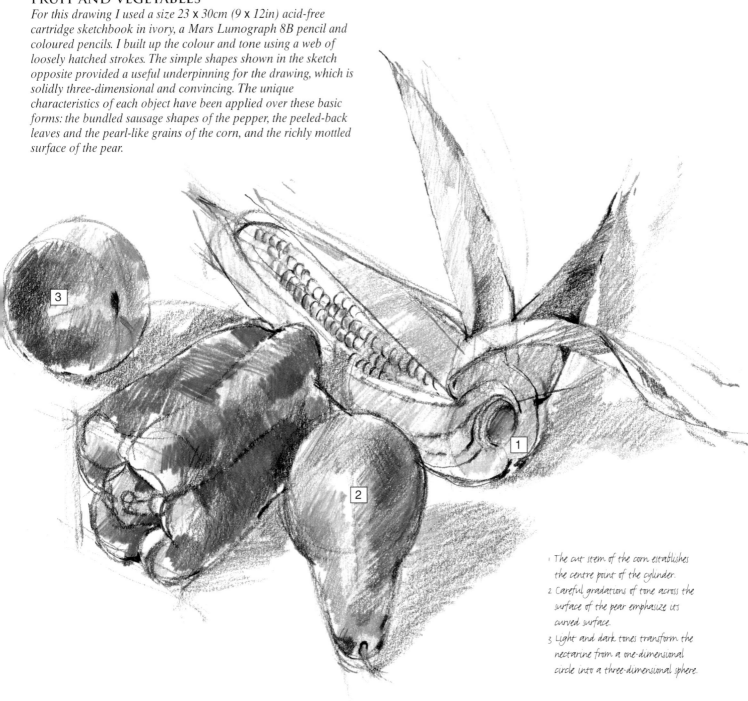

1 The cut stem of the corn establishes the centre point of the cylinder.
2 Careful gradations of tone across the surface of the pear emphasize its curved surface.
3 Light and dark tones transform the nectarine from a one-dimensional circle into a three-dimensional sphere.

'FOUND' STILL LIFES

When we think of a still life we tend to think of a deliberately assembled and arranged collection of objects – the bottles, vases and fruits we all had to draw and paint at school. But still-life arrangements can be found almost everywhere you look in a domestic interior. You probably have one in view at the moment – a collection of plants on a windowsill, some ornaments on a mantelpiece perhaps, or a display of family photographs on an occasional table.

The kitchen is undoubtedly the best source of these 'found' still lifes: here you will see piles of fruit and vegetables in dishes and baskets, kitchen utensils up-ended in jars or hanging from hooks, and china piled high in cupboards and displayed on shelves. It is natural to want to organize the objects around us to look pleasing, so you can almost always find an interesting and attractive arrangement ready made. I often sketch the items in my studio, my home and in the homes I visit.

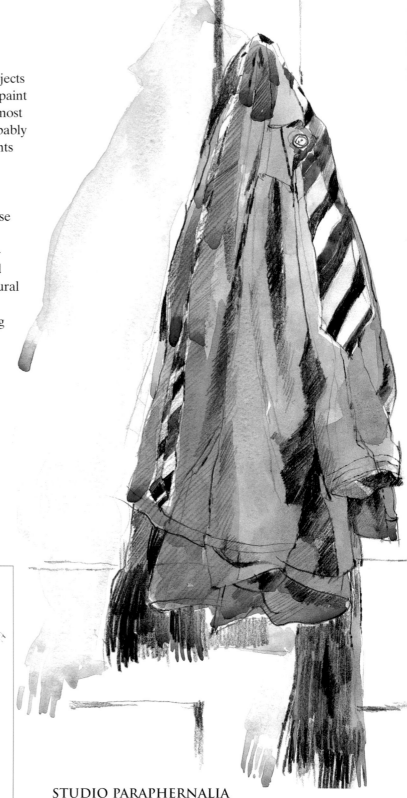

JACKET ON A DOOR
My jacket hanging on the back of the studio door caught my eye one day, and I decided to draw it. I made quite a detailed drawing, using a 4B pencil for the main outlines and an 8B for the dark shadows. I was particularly interested in the weight of the fabric and the way the garment fell from the hook. When the drawing was finished I laid on washes of watercolour.

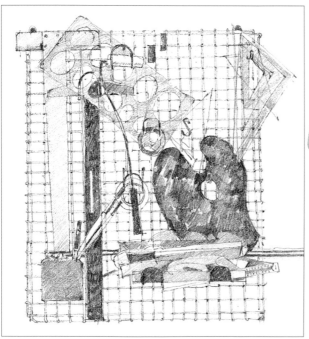

STUDIO PARAPHERNALIA
A mesh grill hangs above my drawing board in the studio and provides convenient storage for all my drawing tools. I decided to draw it as an exercise because it is a fairly complicated subject, with lots of interesting shapes but very little depth. The mesh helped a great deal because it provided a regular grid against which I could measure the size and location of each of the elements. I used a B and a 4B pencil on cartridge paper.

DECKCHAIRS

Deckchairs are difficult to draw because of the effect of perspective on the different angles and the 'negative shapes'. So they make a good practice subject. I drew these in 4B pencil on acid-free paper.

BLUE CHAIR AT LES BASSACS

This drawing was made very quickly indeed. I made a loose pencil drawing and then laid on colour using a wet-in-wet watercolour technique. I like the looseness of this, whereas, on the other hand, the colour on the chequered jug is quite carefully applied to capture its unique character.

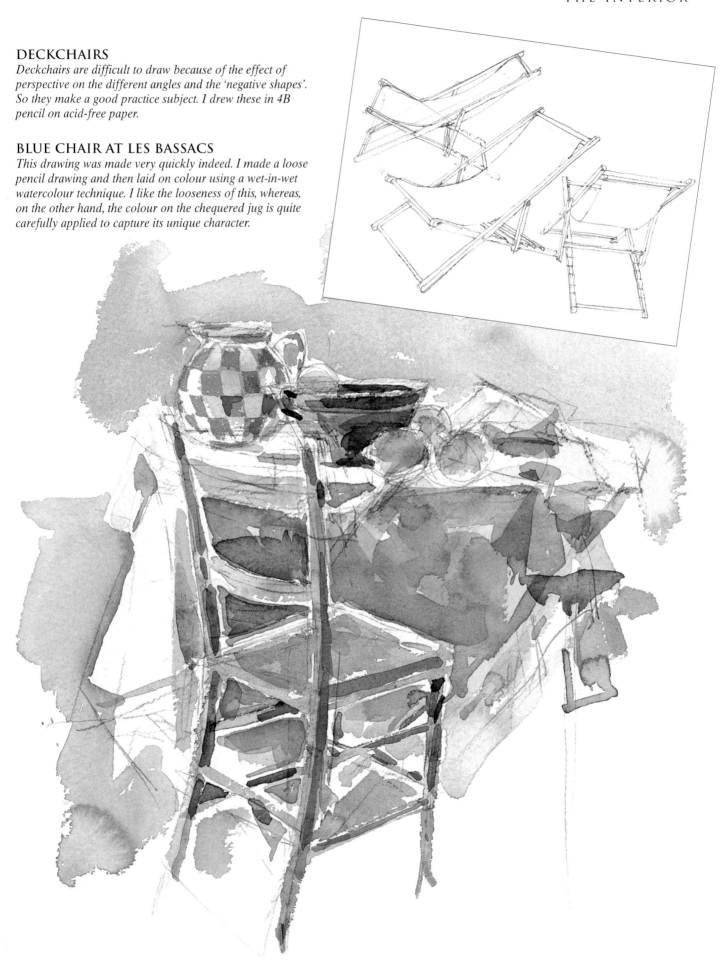

SKETCHING WITH OILS OR ACRYLICS

Oil and acrylic paints have a wonderfully direct quality, especially when they are applied *alla prima* in a single session. This method of working is ideal for sketching, and many artists have used this way to work directly from the subject. Both the great English landscape painters of the nineteenth century, John Constable (1776–1837) and J. M. W. Turner (1775–1851), made landscape sketches in oil on small panels. Constable also made some of his sky studies in oil on paper and card.

These days artists can use special papers that are embossed to resemble canvas and are ready primed for use with oils or acrylics. They can be bought as loose sheets or in sketchpads of various sizes. Note that if the paper is prepared for oil paint it should not be used for acrylic paint, which is water-based. However, a support that is primed for acrylics can also be used for oils. If in

doubt, buy a pad that states clearly that it is primed for both oil and acrylic.

It is a good idea to change medium from time to time to give yourself new challenges. Oil and acrylic paints force you to be direct, but they also allow you to handle the paint, push it around the support, and manipulate it in a way that you cannot do with watercolour.

LILIES

This study of lilies is interesting because I worked in oil on a dark, transparent, acrylic ground, which might seem odd when my subject was white flowers. However, the white petals really stand out against the dark background, and the complexity of the flower forms and leaves can be seen very clearly. The ground also provides a unifying tone that holds the whole image together. I completed the painting by making the background more solid, using the colour to cut back into the flower shapes to sharpen the silhouette.

TWO STUDIES OF ONIONS AND MUSHROOMS

I made two studies of the same set-up in rapid succession. I worked quickly and was able to investigate different aspects of the subject.

The first study (right) was made very quickly with oil paint thinned with turpentine. I worked directly, drawing with the brush, then blocking in the main areas of colour. The tones and reflected colour on the onion were applied with bold strokes of the brush, while the background colour was scumbled on with washy paint. The lively brushwork gives the image a special kind of energy, and you can sense the speed with which it was made.

The second study (below) is more considered. I worked with fairly thin paint in much the same way as before, drawing with the brush and then blocking in the main areas of colour and tone. But I have taken this sketch further, developing the tones on the surface of the onion and the shadows cast on the wall and on the horizontal surface. As a result this version has a more three-dimensional quality, and the shadows are now an important part of the composition.

CUT FLOWERS

I always have vases of flowers wherever I am, whether in my home or in my studio. They gladden the heart even on the greyest winter day. Flowers are available year round at very little cost, and the entire world has become like a local flower garden, with blooms being flown from all corners of the globe, from the Netherlands to Cyprus and Africa. The choice is bewildering, ranging from cottage-garden flowers such as delphiniums to exotic lilies and strange-looking orchids. Flowers are an ideal subject for the artist, with their myriad shapes and brilliant palette of colours. And they remain interesting to draw and paint as they fade and die.

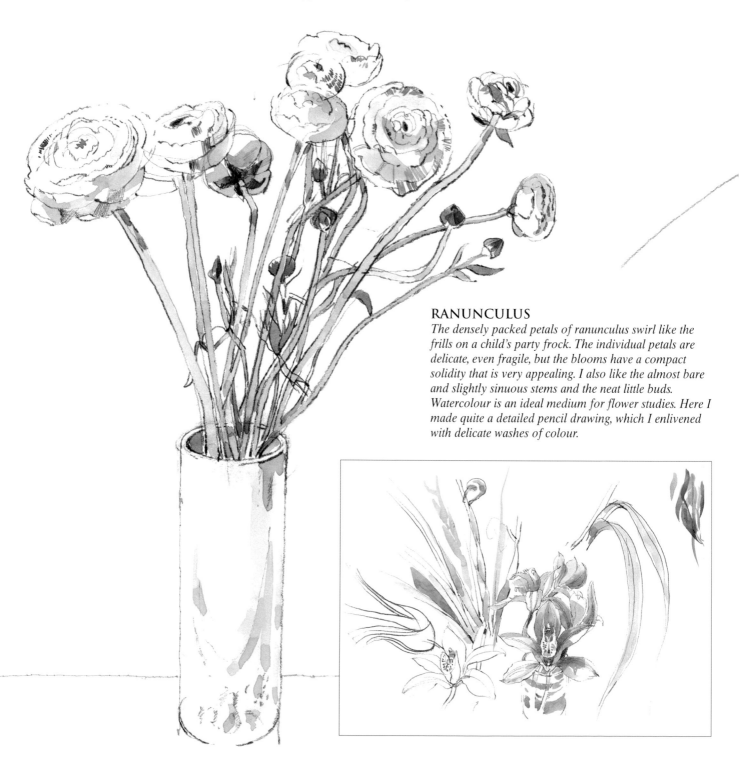

RANUNCULUS
The densely packed petals of ranunculus swirl like the frills on a child's party frock. The individual petals are delicate, even fragile, but the blooms have a compact solidity that is very appealing. I also like the almost bare and slightly sinuous stems and the neat little buds. Watercolour is an ideal medium for flower studies. Here I made quite a detailed pencil drawing, which I enlivened with delicate washes of colour.

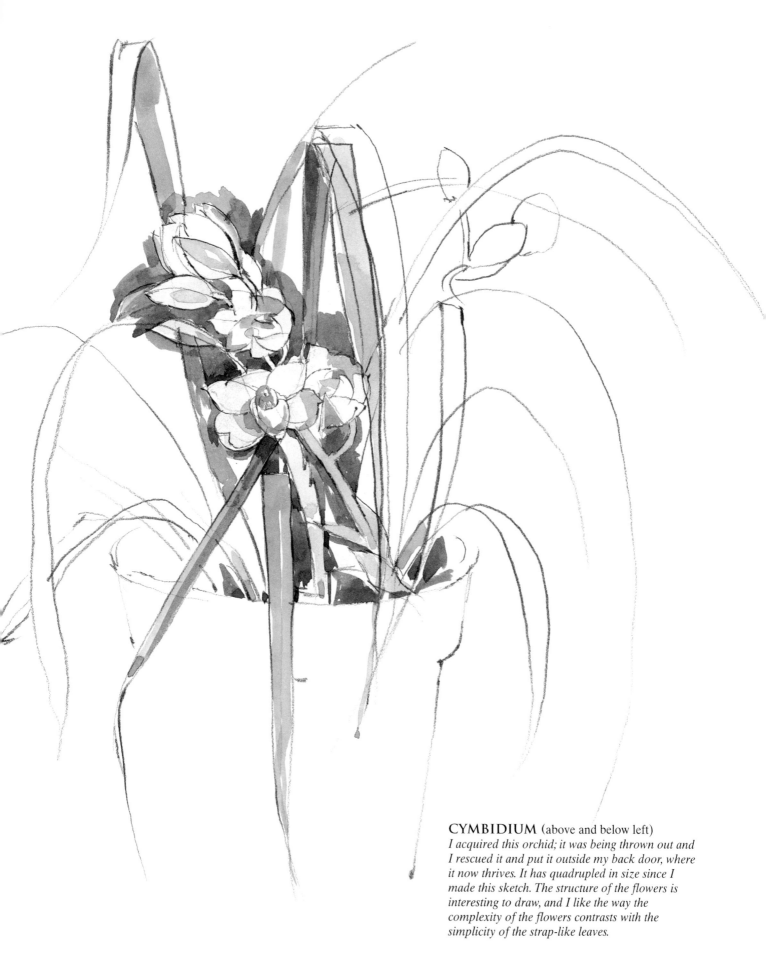

CYMBIDIUM (above and below left)
I acquired this orchid; it was being thrown out and I rescued it and put it outside my back door, where it now thrives. It has quadrupled in size since I made this sketch. The structure of the flowers is interesting to draw, and I like the way the complexity of the flowers contrasts with the simplicity of the strap-like leaves.

FROM SKETCH TO FINISHED PAINTING: TULIPS

Flowers are a lovely subject for the artist, with their vivid colours and infinitely varied petals, leaves and flowerheads. But their rather obvious beauty can be a distraction. Flowers are simply another form of still life, and it is important to find a solid composition, and to observe and analyse the forms and colours with the same rigour that you would apply to any other subject. The

sketchbook is an excellent place to investigate composition. You can experiment with different arrangements, crops and formats, shifting the image around the picture area, removing some elements or emphasizing others. In this case I wanted to highlight the elegant shapes and jewel-like colours of the flowers, so I chose a small, square format and a plain, dark background.

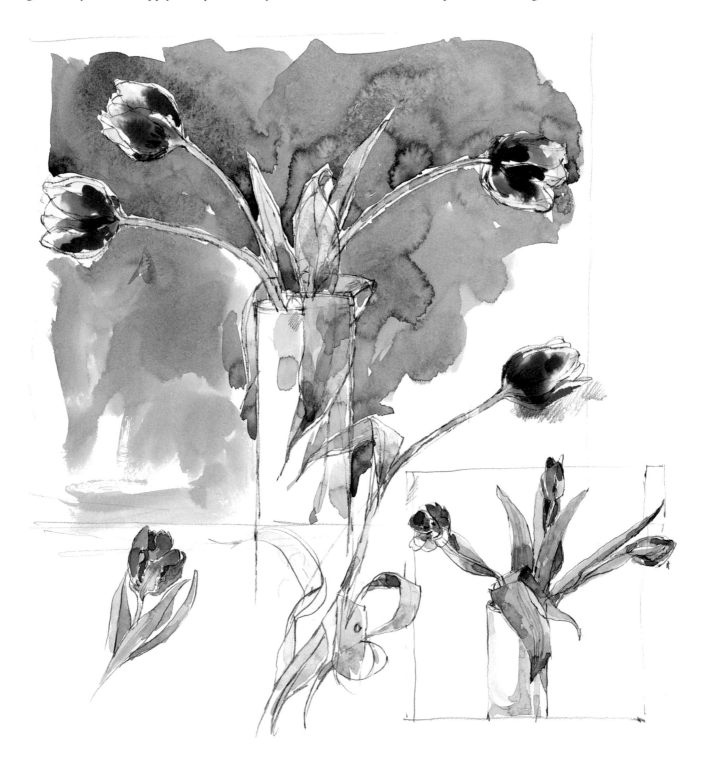

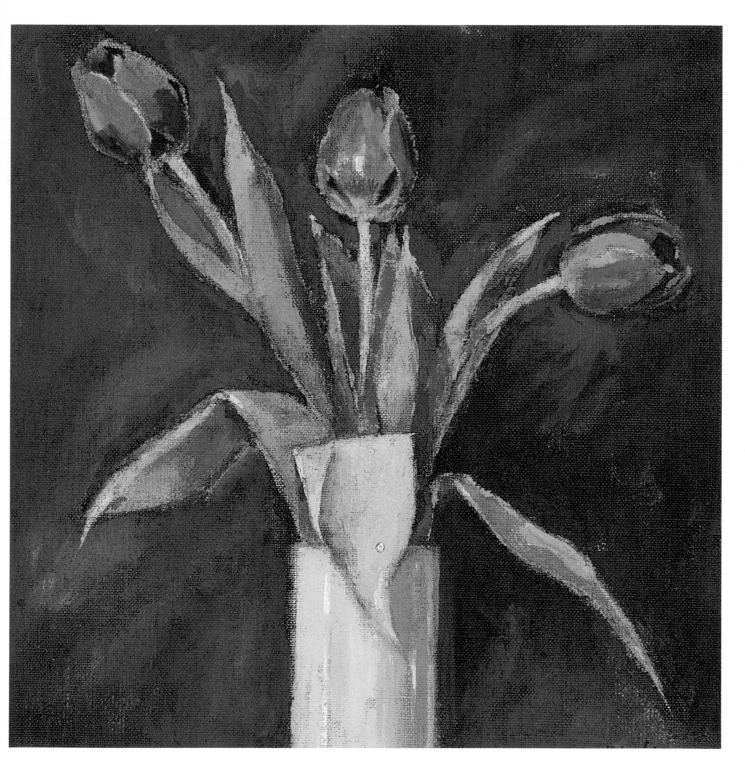

TULIPS
23 x 23cm (9 x 9in), oil on board

I like the simplicity of tulips with their cup-like heads and simple, lance-like leaves. Flower studies are often rather exuberant, but I wanted to make a picture that was more formal and restrained, so I chose a small support and a square format. This combination of subject, format and size gives the image the feeling of something small and rather precious. I have placed the plain, straight-sided

vase so that it is cropped by the base of the picture area. This brings it right on to the picture plane, and combines with the dark background to emphasize the decorative qualities of the subject. I laid in a dark ground and, when that was dry, blocked in the shapes of the flowers and the vase. I developed the image, working quite carefully to create a fairly finished paint surface.

CHAPTER 5
LANDSCAPE

The landscape is a vast, absorbing and constantly changing subject. A sketchbook is an essential tool for the landscape painter who must record the changes wrought by light, weather and the seasons. Studies can range from panoramic vistas to outdoor still lifes of rocks, tree trunks and wildflowers, from the grandeur of craggy mountains to the quiet pleasures of cultivated landscapes. My sketchbooks are full of landscape studies. Some are a record of a beautiful or interesting scene, others were made for a particular project or commission, while others are investigations of phenomena such as the sky before a storm, or the way in which evening light and long shadows can transform a familiar scene. It is worth making studies of the sky because as the source of light and weather it affects the appearance of the landscape even when it is not included in the image. The great English landscape painter John Constable (1776–1837) sketched the sky again and again, finding it an endless source of inspiration.

APPLECROSS, WESTER ROSS, SCOTLAND (right)
This was one of those spring days when the weather cannot make up its mind. One moment the landscape was bathed in spring sunshine, the next it had disappeared into a blizzard. I sketched from the shelter of my car, using a 7B pencil for the winding road, the sloping terrain, the gnarled and twisted trees, and the dark, slanting shadows. A few washes of watercolour boldly applied capture the special brilliance of spring light.

INVERARY
One of many sketches I made of the buildings in this small, picturesque Scottish village.

LIGHT AND ATMOSPHERE

The fall of light helps create much of the atmosphere and perceived mood of a place. The city of Venice consists of a series of islands scattered across a lagoon, and everywhere there is water that reflects the sky, giving an overall luminous quality that is unique. An infinite variety of light effects means that wherever you look there is a potential picture for someone with sketchbook in hand.

1 Dashed brushmarks are a visual shorthand for the choppy water.
2 Paler washes in the distance give a sense of recession.
3 Shadows cast by the mooring posts are broken up by the moving water.

THE FISH MARKET, VENICE (below)

I sketched the entrance to the fish market on the day after the study of Santa Maria della Salute. The massive archway framing the dark interior was a compelling subject. Again a sense of scale is important – the figures outside and those within give a clue to the size of the archway.

Fish Market
Venice March 92

SANTA MARIA DELLA SALUTE, VENICE

I was wandering through the narrow streets with my sketchbook under my arm when I came across a spectacular view of Santa Maria della Salute. It was late afternoon and the sun was hanging low in the sky, its light filtered through misty cloud. I found a comfortable spot and started to sketch the scene, paying special attention to the relative size of the mooring posts as they receded across the water, and the scale of the buildings in the distance – it was important to get these right in order to create a sense of space. I had to work across the gutter to accommodate the broad vista. I unpacked my box of watercolours and filled a jar with water from the canal. Then I started to apply watercolour, working fast and using a combination of broad washes and more detailed work. The white of the paper was left to stand for the reflection of the sun on the choppy waters.

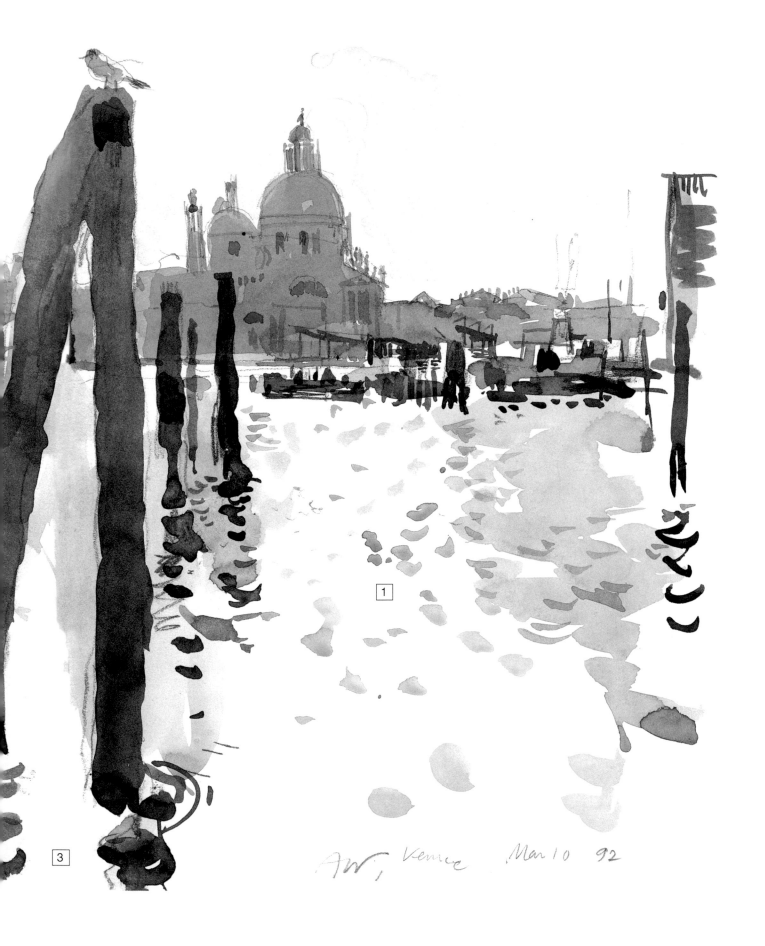

1

3

AW, Venice. Mar 10 92

MEDIA FOR LANDSCAPE

Which materials you use for sketching out of doors will depend on practical considerations, such as portability and whether you are working near a base. Personal preference also comes into it, and what you have to hand. From time to time you will also feel the need to experiment with new materials – something will catch your eye, or a particular subject will suggest a particular medium or technique, or you might simply want to try some different effects. A new medium keeps your work fresh by presenting new problems that need to be solved.

 The sketches here have been made in a range of media including pencil, watercolour and oil pastel.

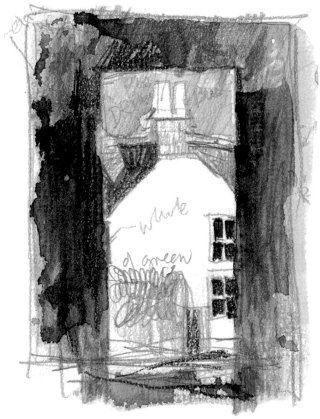

THROUGH A DOOR IN ULLAPOOL (right)
This tiny sketch was made in a café in Ullapool, Scotland. The view was beautifully framed by the door, and I was especially taken with the bright end wall of the house. I worked in graphite pencil and then applied watercolour. Because the graphite is so shiny the water has resisted, creating interesting puddles and textures on the door frame – a happy accident!

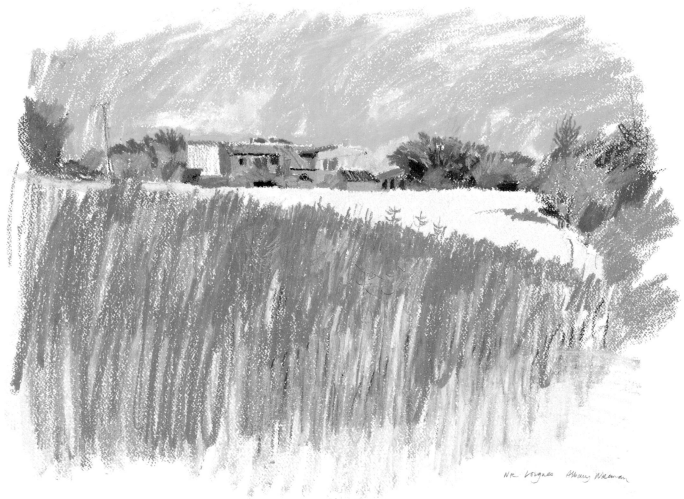

PLOCKTON

The tiny village of Plockton in Scotland achieved some national fame when it was used to film a BBC TV series called Hamish McBeth. *It is a holiday village at the end of Loch Carron, near the Kyle of Lochalsh ferry, a truly beautiful part of the country. But the real treat is to come round a corner in the Highlands and see these palm trees towering over the typically Scottish flat-fronted village houses. The Gulf Stream accounts for the mild climate and the exotic flora.*

NEAR LORGUES IN THE VAR REGION OF FRANCE (left)

This brightly coloured study was made in oil pastel on watercolour paper and has an entirely different feel from the other images on this page. The nature of the medium forced me to work quite boldly, and the clarity of the colour gives the sketch a special vibrancy. I do not use oil pastel very often, but I enjoyed making this sketch and I am quite pleased with the result – it is bold and punchy. It is also quite large – 46 x 61cm (18 x 24in).

LETHERINGHAM, SUFFOLK

This pencil drawing was made with a 7B black pencil. I liked the way the house and farm buildings hug the slope of the hill when viewed from across the field. I used a variety of solid tones and descriptive marks. Pencil really is a remarkably versatile medium.

GARDENS

Gardens are very special places. In them we can be at one with nature – but with a nature that has been organized and tamed. In many ways gardeners are like artists, 'composing' in terms of shape, colour, texture and scale. So it is hardly surprising that artists have returned to the subject of gardens, both formal and domestic, time and time again. The French artist Claude Monet's (1840–1926) garden at Giverny with its famous waterlily pond is the most well-known example of an artist's garden, for he created the garden and painted it repeatedly.

The watercolour opposite was made at Inverewe Gardens on the west coast of Scotland. A tropical garden with towering palms and other exotics comes as a bit of a surprise in this area, but the climate is mild because the warm waters of the Gulf Stream wash this part of the country. The garden was established by Osgood MacKenzie and developed after his death by his daughter. It has been in the hands of the Scottish National Trust since 1952. There are some giant rhododendron shrubs and an amazing magnolia tree that is 23m (75ft) in circumference and 9m (30ft) high. It is a truly amazing place and full of visual treats.

PARQUE DE MARIA LUISA, SEVILLE
This marvellous town-centre garden had some wonderful specimen trees, including many different palms and huge eucalyptus. There were formal paths and a rather imposing statue of Maria Luisa. I worked primarily in pencil, combining line with areas of hatched and solid tone, and then applied a wash of variegated green. The technique is very different from that used for the other sketch, but this is much smaller and was made in less time.

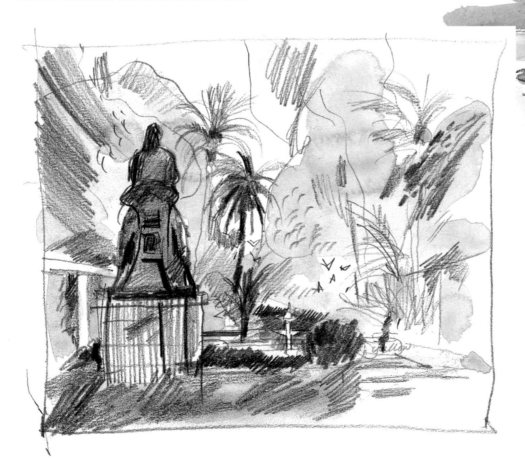

INVEREWE GARDENS, NEAR POOLEWE, SCOTLAND

I sat myself at this particular spot because it allowed me to include the sinuous curve of the wall; curving lines draw the eye into the composition and are inherently pleasing. I worked quickly with pencil on a watercolour sketchpad, then applied the watercolour, paying special attention to the shapes and textures of the foliage.

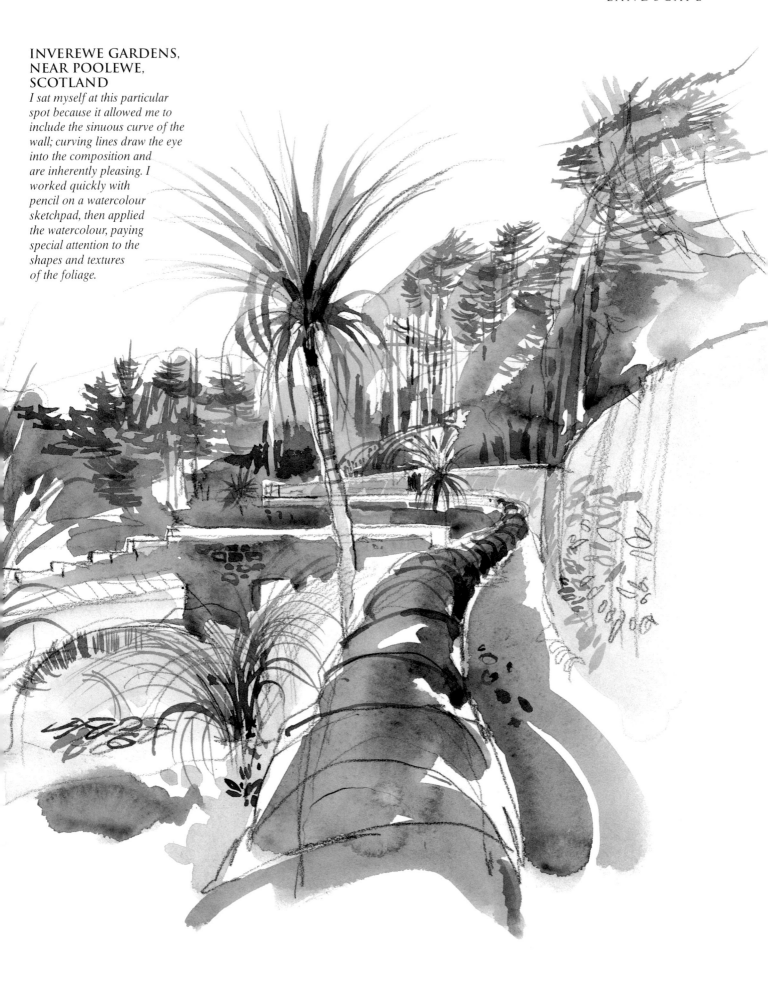

TREES IN WINTER

Trees are infinitely varied in shape, colour and growing habit. They provide important masses of colour, pattern and texture in the landscape, but they can be a daunting subject for the sketcher because they are so big and their structure of branches, twigs and leaves looks complicated. The best way to approach the subject is to ignore the detail and concentrate on the underlying forms.

When deciduous trees are bare of foliage the tracery of their branches looks complex, but consider the way the tree grows: the boughs grow from the trunk, and the branches and twigs grow out of each other in a logical pattern, becoming thinner towards the outer edge of the tree. Use the tip of a sharp pencil or the tip of a brush for the thinnest branches and twigs, and work towards the end of the branch or twig. You will find a flicking movement useful for the smallest twigs in both pencil and brush. In some species the small twigs at the very ends of the branches create a dense mesh around the silhouette of the tree – this can be described with scribbled hatching. Blur it in places by smudging with a fingertip.

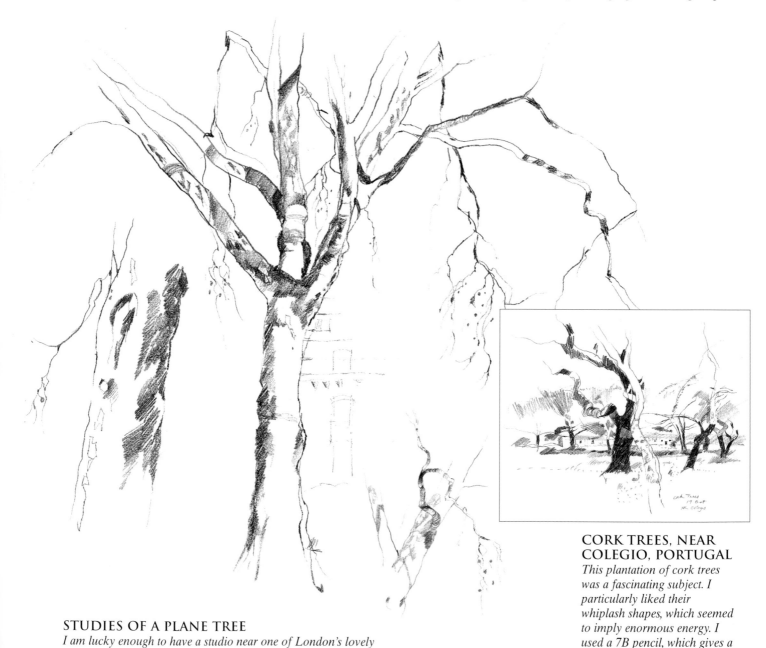

STUDIES OF A PLANE TREE
I am lucky enough to have a studio near one of London's lovely squares. The trees are a delight at any season. I made this study of a particularly graceful specimen one January.

CORK TREES, NEAR COLEGIO, PORTUGAL
This plantation of cork trees was a fascinating subject. I particularly liked their whiplash shapes, which seemed to imply enormous energy. I used a 7B pencil, which gives a good dark line and a solid black tone.

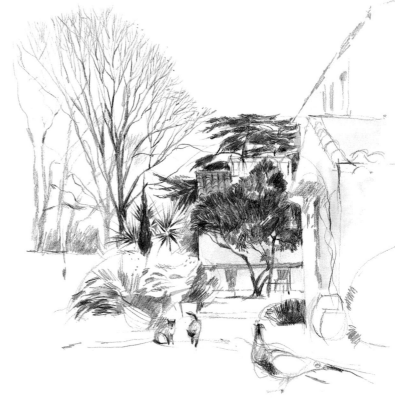

TREE OF HEAVEN (above)

*This sketch was made in autumn, when
there were still some leaves on the trees.
I used a pencil for the skeleton of the
tree and for some of the foliage, and
then added watercolour, using the tip
of the brush to make marks that suggest
the character of the foliage.*

LA BRIHE, FRANCE (above right)

*The grounds of this lovely house in France
have some beautiful trees, including lime,
cypress, cedar, palms and a myrtle. In
mid-winter the contrast between the
evergreens, which cling on to their leaves,
and the nakedness of the deciduous trees,
is at its most marked. I worked primarily
in pencil, but added some washes of
colour over the buildings and the
dark evergreens.*

CHESTNUT TREES IN SILHOUETTE

*I sketched this fine pair one Christmas
Day in Gascony, France. I used a 7B
pencil to obtain the blackness of the
trunks seen against the light, with fine,
flicking marks for the mesh of tiny
twigs at the very end of the branches.*

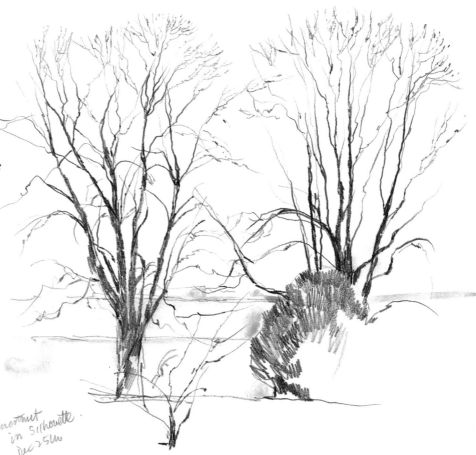

89

TREES IN SUMMER

In summer, when the trees are in leaf, study the way the foliage forms masses around the main boughs and branches. Draw these as simple outlines, then look for the areas of light and dark; the uppermost areas will be lighter because they receive the light. The skeleton of trunk and branches is there underneath giving the tree form, just as the human skeleton provides the armature for the clothed figure. Reduce the tree to simple shapes, but be aware of the underlying structures. In that way you will produce images that are solidly three-dimensional while capturing the unique character of each tree.

Try to discover the special characteristics of each tree. The branches of the Lombardy poplar, for instance, are equal in length and grow upwards from the main trunk, giving the tree an elegant, lance-like shape. Look for the rope-like masses of foliage that clasp the main trunk. The side branches are quite thin and in windy conditions they are blown about, so the tree looks feathery and loses its compact shape. Ensure that your pencil and brushmarks follow the upward direction of growth of the branches.

The oak, on the other hand, has a broad, compact, domed crown and the branches radiate from the main trunk. The oak often has an asymmetric outline, while the horse chestnut is more symmetrical with denser foliage.

Green can be a difficult colour to use. I tend to use sap green as my base and modify it with cobalt and raw sienna. I sometimes use Hooker's green.

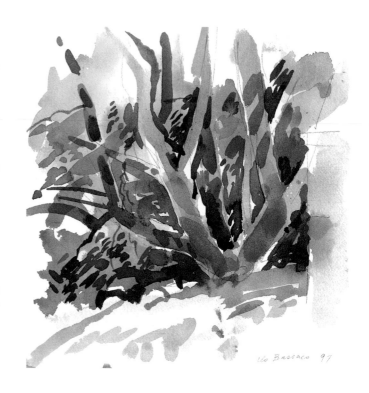

LIME TREES IN LES BASSACS, FRANCE
These trees are at the back of the house and in the morning they appear light against dark, but later in the day they are dark against light. I made this sketch directly with watercolour using a big squirrel brush, with only a tiny bit of pencil work to locate the trunks. I was trying to capture the dappled light effects.

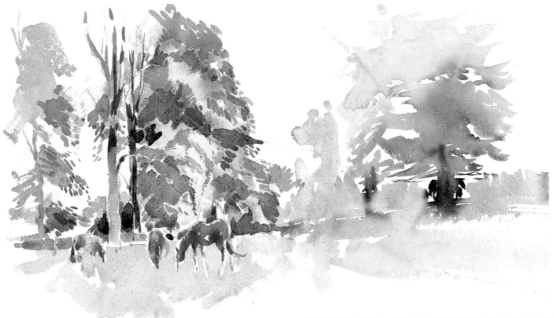

WHERWELL, HAMPSHIRE, ENGLAND
This rather delicate sketch was made on a warm wet day in July when I was sheltering under a tree from the rain. You can see that the sketch is unfinished on the right-hand side.

MOULIN DE MONTREUX

This sketch was made in May in northern France. I made it from my hotel window – the room was in a bridge directly over the river. At this time of the year the greens are sharp and vibrant. I used pencil and watercolour which I applied wet-in-wet and wet-on-dry. The willows on the riverbank were pale green and willowy.

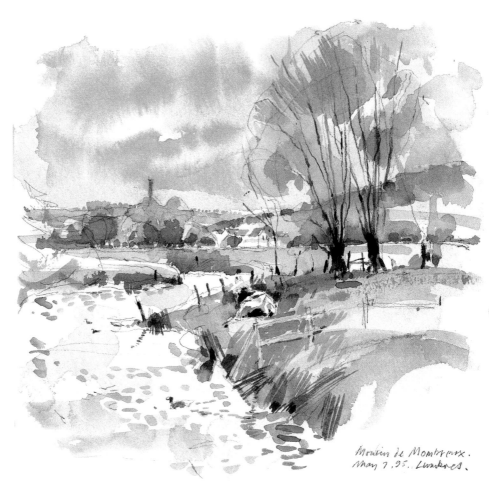

Moulin de Montreux.
May 7.95. Limbres.

COUNTRY ROAD IN COLLEGIO, PORTUGAL

I have included this sketch to show that you do not need green to paint trees, even in mid-summer. This was also painted directly using a big squirrel brush, and a limited palette of colours based on cobalt and raw sienna.

collegio portugal July 96

MIXING GREEN

Green, the colour of nature, is the most important, varied and difficult colour in the landscape painter's palette. There are two main ways of creating the greens you need. The first is to use the proprietary ready-made greens in your paintbox; these are easy to use, but they can look shrill and unnatural. Modify them by adding other colours: a touch of a complementary red or ochre will mute a green effectively, and you can produce a whole range of hues in this way.

The second method is to mix your own greens from primary blues and yellows and it is a good idea to practise doing this. You will gain an understanding of the way that colours behave in mixes, and you will be forced to really look for the subtle differences between one green and another, and to notice the way that colours change as the light changes. Also, the more you look the more you see, and we all know that the learning process never stops, which is why it is so important to work directly from nature whenever you can. Your sketchbook is the ideal place to carry out these mixing experiments. The landscape sketches on these pages were painted without a ready-made green.

OPPÈDE LE VIEUX (below)
I made this quick sketch to show the use of contrasting light and dark, and warm and cool, colours. The composition is quite strong, with the road leading into the picture and disappearing behind the massive walls. My palette consisted of French ultramarine and raw sienna.

VIENS
It was an extremely hot day and I was working with some students who wanted me to do a demonstration. I started by doing a tonal painting in blue, and then I took gamboge across the image; where it overlapped the blue it created a green. Then I added some washes of red to warm it up.

Tip:

🌸 A range of greens can be mixed from the primary colours yellow and blue, with different pairs producing entirely different greens. A cool yellow with a cool blue will give you the brightest green. So cerulean (a cool green) mixed with lemon yellow (a cool yellow) will give you a bright 'spring leaf' green. French ultramarine is a relatively warm blue, and all the greens mixed from it are slightly muted as a result – but these are just the colours you need to produce an interesting and convincing landscape

1 Cerulean
2 Gamboge
3 Light red

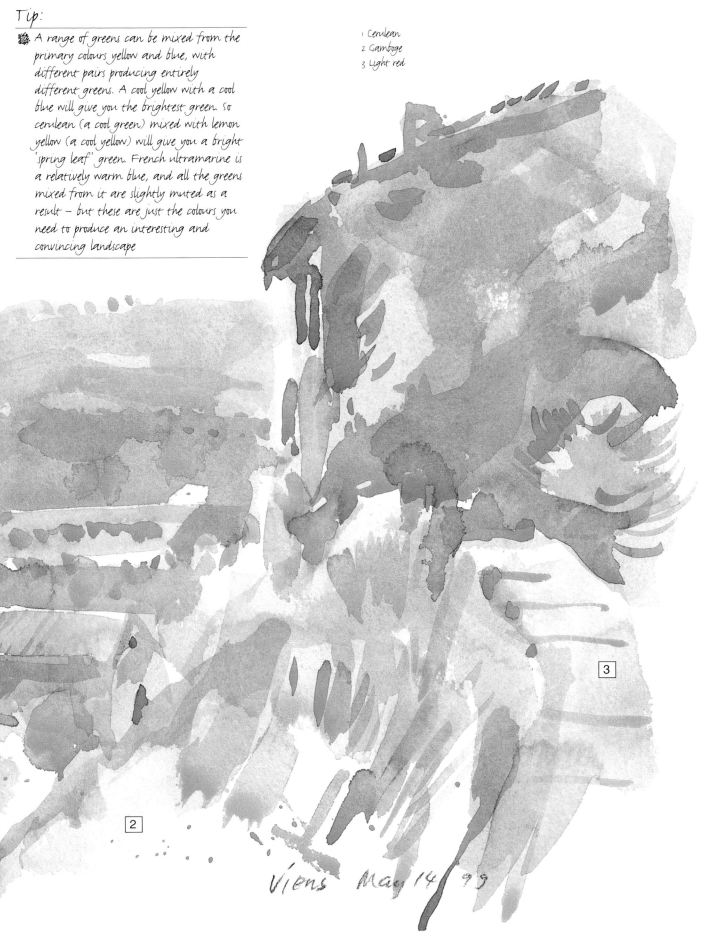

Viens May 14/ 99

SKETCHING ON HOLIDAY

For many people, holidays are the only time they can devote themselves seriously to sketching. I am lucky because, as a professional artist, drawing and sketching is part of my job description. So if I receive a commission to paint a particular landscape or building, I have to go off with my sketchbook and gather the material. But even so, my holidays abroad and jaunts around Britain provide a fantastic opportunity to observe, sketch, record and think. Sometimes the material stays in my sketchbook as a happy memory, sometimes it is resurrected at a later date and developed into a more finished image. Occasionally, looking at a landscape or a building, for example, will trigger a train of thought, or suggest an idea for a project. But sketches made at leisure, with no pressure, have a special quality. So whenever you go away, remember to take a sketching kit with you. Take a camera, too, by all means, but do not rely on it. You 'own' the subjects you contemplate long enough to draw them in a distinctive and personal way, and you will find that the memories and details stay with you.

All the sketches on these pages were made at locations that are within 16km (10 miles) of each other in the Luberon region of France.

Tip:

🍂 Keep your holiday sketching kit simple. Take a small sketchbook for trips away from base. A pencil or pen are all you need. If you like colour take a handful of coloured pencils, or a tiny sketching box of watercolours. Do not burden yourself, and do not take so much equipment that you make yourself conspicuous.

ROUSSILLON (below right)
This sketch was also made directly with the brush. The famous Roussillon ochre mines are nearby, and all the houses are either red ochre or yellow ochre in colour.

VIEW FROM VIRGINIA'S GARDEN (below)
Working wet-on-dry with watercolour gives crisp edges, which give the image definition, and the overlapping of washes creates variations of tone and a sense of depth. I made this sketch directly with the brush, with no pencil work at all.

HAMEAU DES YVES, LUBERON
I liked this view because it shows a working agricultural landscape rather than an especially picturesque one. I also particularly liked the group of buildings, and worked the scene outwards from there. The rows of vines lead the eye into the image, and the warm earth colours of the buildings provide an interesting contrast to the cool green trees and the rolling hills beyond. I used pencil and watercolour on a Rough watercolour paper. The square format of this sketchbook gave me a good landscape shape when I worked across both pages.

DERELICT FARMHOUSE
The building had a marvellous stepped shape, and I liked the way that some surfaces were taking the light directly while others were in shadow. I used a combination of pencil and a very loose wet-in-wet watercolour technique. That single touch of scarlet really does draw the eye.

SKETCHING IN WINTER

Landscape sketching is not simply a fair weather activity; the winter months have plenty to offer in terms of light and weather conditions. The sun is low in the sky, and when it shows itself it casts long, low shadows that make strange patterns on the landscape. Trees are skeletal and colours are muted, and the skies are often turbulent.

Snow can transform the appearance of a scene, concealing details and giving it a sense of unity that is absent at other times. Rain and mist soften the light and sometimes play tricks with spatial arrangements, blurring details so that our perceptions are confused. The car is a wonderful aid for the winter sketcher, providing shelter, warmth and a temporary retreat, so you can continue to sketch in even the most inclement conditions. You can also make the most of those magical moments when the clouds part and the sunlight dances across the landscape.

Except for the Gascony landscape below, the sketches on these pages were made on a trip to the Scottish Highlands in December. Their energy and immediacy brings back every detail with amazing clarity – a not-to-be-overlooked benefit of keeping a sketchbook!

GASCONY
Watercolour in an Arches sketchbook of a Gascony landscape in winter painted from my car.

GLENCOE (above)
The bulk of the mountains dominates the valley, dwarfing the trees and the road. I worked freely and fast, drawing the shapes of the mountains, the curving line of the road, and details such as the wintry trees and the sheep in the left foreground. The scribbled indication of grasses and vegetation gives a sense of scale, brings the area forward on to the picture plane, and suggests depth in the picture. I applied loose washes of colour with a large brush. When these were dry I used the tip of the brush to add texture and detail to the trees and the foreground. The image has the directness and freshness that I like to see in sketches. I made another version of this in the studio; the latter one is more resolved, but I must admit I prefer the original sketch.

CALEDONIAN CANAL BASIN

This study was made on a bleak day in December. It was blustery and the wind was whipping up the surface of the water. The small figure in front of the house shows her umbrella blown inside out with the wind. The sky kept on changing. I used a combination of pencil and watercolour to make this sketch. The tiny touches of red and orange around the centre of the image draw the eye – it is surprising how a little spot of a hot colour will dominate in a predominantly cool painting.

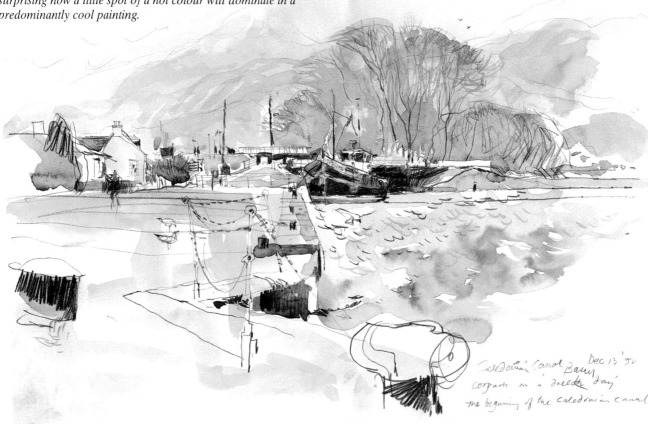

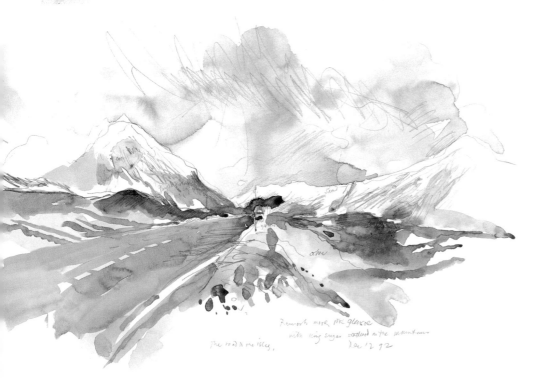

RANNOCH MOOR

This was another December day on remote Rannoch Moor. I parked my car and worked inside, balancing my sketchbook on the dashboard. The peaks were snow-covered – my notes on the sketch say 'Rannoch Moor, near Glencoe with icing sugar scattered on the mountains'. I used a vigorous scribbled line to describe the snow-laden sky and the precipitous slopes of the mountains. I then applied loose washes of watercolour, leaving the white of the paper to stand for the snowy peaks and for the road markings. The tall yellow poles are intended to stand above the snow and mark the line of the road in very heavy snow conditions.

97

SKIES

The sky is an important and changeable aspect of the landscape and worth observing and recording whenever you can. The English painter John Constable (1776–1837) was a great exponent of cloud and sky studies, painting and drawing them constantly, making rapid oil sketches on small boards, card or paper. He referred to this activity as 'skying' and often annotated these sketches with copious notes about the time of day, the light and the weather conditions. This is very good practice.

The sky changes subtly, and sometimes dramatically, throughout the day, and can even change from one moment to the next. Its colour and its degree of brightness depend on factors such as the amount of cloud cover, the quantities of dust and water droplets in the air, and the position and strength of the sun. It is often very blue after a shower of rain, while on a sunny summer's day it may be bright but not very blue, surprisingly, because of the dust particles in the air.

Notice that clouds are not flat white shapes, but three-dimensional forms, with a top and bottom. The side that faces the sun will be lighter than the side away from the sun, which will be in its own shadow. Although cloud shapes vary considerably, they conform to recognizable patterns. Cirrus are the highest and most delicate of the common cloud patterns, often forming a high, wispy blanket. Cumulus is the typical 'cotton wool' cloud of a fine summer's day; the magnificent billowing shape makes for interesting skies. Stratus is the lowest of all the clouds; it is the grey, brooding blanket of cloud that so often you see on rainy days.

ISLE OF WIGHT (right)
This lowering sky was painted from the beach at Bembridge. The row of brightly coloured beach huts look rather jolly by contrast. The watercolour wash has broken over the texture of the paper, and the sparkles of white paper that are revealed suggest the brightness behind the rain clouds.

PORTUGUESE SKY (left)
This washy study was made in Portugal using cerulean, Naples yellow, ultramarine blue and alizarin crimson. Cerulean is a useful blue for southern and Mediterranean skies.

ULLAPOOL IN THE WESTERN ISLES (right)
This is a real northern sky, drawn from the comfort of my camper van. I worked more or less directly in watercolour – there is a little pencil drawing – and used the same colour in the sky as I did in the Portuguese sky. I liked the way the rooftops just peeked over the rising ground. The sky was made using very wet washes that bled into each other. The darkest area was applied once the rest of the sky was dry. The patches of snow lying on the mountain tops were masked out with masking fluid; I could do this in my mobile studio, but masking fluid is fiddly to use if you are away from your base.

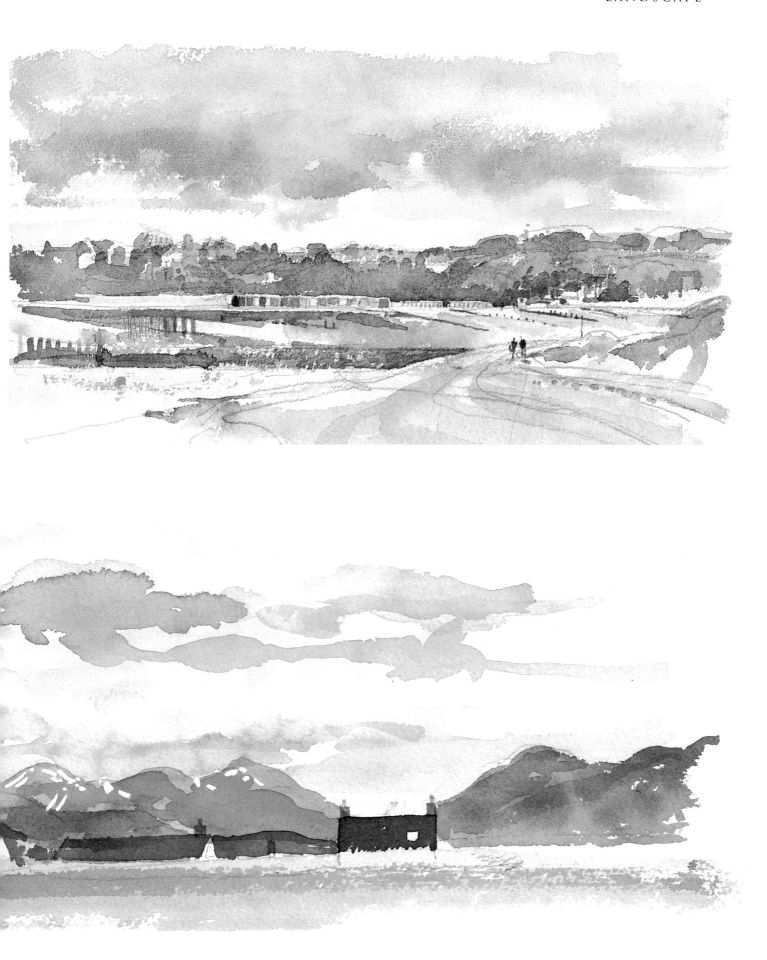

SEASCAPES

The sea is really a huge mirror to the sky. It reflects and distorts the light, giving coastal areas a special luminosity on sunny days. When we are on the coast we not only see a huge body of water, we also see a huge, uninterrupted sky. This sense of space and airiness can be quite giddy-making, especially if you spend a lot of time in an urban environment, hemmed in by buildings, with the sky revealed as a tiny sliver between the canyons of brick. Similar effects are found on flat lands and high areas, on plains, plateaux, on moorlands and mountain tops. You can watch belts of rain advancing towards you, the shadows cast by clouds plunging one area after another into darkness, and cloud systems building in the sky. Sunrise and sunsets have a special drama over the sea; not only are they centre stage, but the effects are often magnificently mirrored and magnified in the water's surface.

The sea seems to be more moody than the land. One minute it is mirror-smooth, a milky blue-green in colour, and strangely silent – so that the voices of swimmers far out carry quite clearly. At other times it is heaving, sullen and leaden, or raging and dangerous, pounding the shore with huge waves with the power to wreak destruction.

Study the sea in all its moods and manifestations; you will be surprised by the richness of the material. I find watercolour the most sympathetic medium for sketching the sea. Generally I work directly with the brush with little, if any, pencil work. The fluidity of the medium permits subtle blendings of colour and tone, while the white of the support provides the brilliance and sparkle that the subject demands.

ERQUY, BRITTANY, FRANCE
This simple watercolour was made on a rather smooth paper in my Roberson sketchbook – you cannot mess about with the paint too much or the paper will cockle. The thin, transparent washes combined with the smoothness of the paper have given the image a rather pleasing luminosity. Very small amounts of crisp detail can really pull an image together. Here, the detail on the lighthouse and the suggestion of its reflection in the water bring this area forward, while the tiny dots of colour applied with the very tip of the brush capture the broken surface of the water. The charm of sketches lies in the sense that you have responded directly to a subject – so look for the simple solution, the 'shorthand' that captures the essence of the subject you are depicting.

DIEPPE, FRANCE (right)
This was painted at evening and the sea appears brighter than the sky, which is not actually possible as the sky is always the lightest part of the landscape. Here the setting sun is hidden from our view. I like the way the figures are seen as dark silhouettes against the bright water.

NEAR BEMBRIDGE, ISLE OF WIGHT
I painted this sketch at low tide. The shoreline is glazed with water, and shallow pools are interspersed with weed-covered rocks and bundles of seaweed. When low tide falls at dusk people love to wander on the strand, peering at the debris left by the sea, and children and dogs race up and down, deliberately splashing through the watery shallows. The general wetness is highly reflective, so the scene seems to shimmer and dance with light. The combination of Rough paper and a fairly dry brush captures the sparkling light. I have suggested the people on the strand with tiny strokes and dots of colour, which seems quite effective.

Erquy 18 mars 90

Dieppe
13 Mar '93

FROM SKETCH TO FINISHED PAINTING: MIREPOIX, GERS

These sketches were made during a cold winter in south-west France. My eye was caught by the starkness of the rows of denuded vine stems against the frosty ground. In both cases I worked in my car, using it as a shelter from the cold and as a mobile studio. It is almost impossible to work out of doors when it is bitterly cold, so a warm car extends the opportunities to work *en plein air*.

In the sketch below the viewpoint emphasizes the drama of the converging rows of vines, while the yellow farmhouse at the end provides a terrific focal point. I sketched the bare bones of the landscape in pencil. The tangle of frosted vegetation made an intricate pattern in the foreground, so I 'drew' the stems and grasses in masking fluid applied with a twig. I then applied washes of colour using a limited 'winter' palette of Payne's grey, light red and raw sienna. Notice the way the tall, dark post in the foreground, and the clumps of grasses, bring this area forward and enhance the sense of recession.

The second study was made late in the day, when the weak winter sun was struggling to show through a misty sky. I love the cool cast this sort of light gives to the landscape. I worked in pencil, using a combination of line and scribbled tones for the village, which is seen in silhouette against the setting sun. I then applied washes of mixed greys and lemon yellow, with a touch of raw sienna in the foreground.

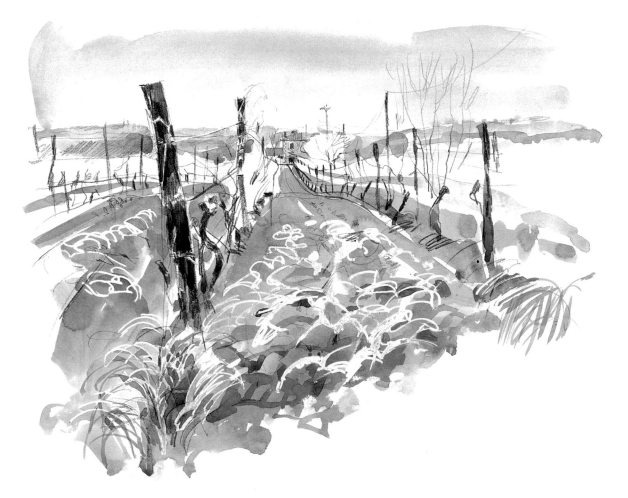

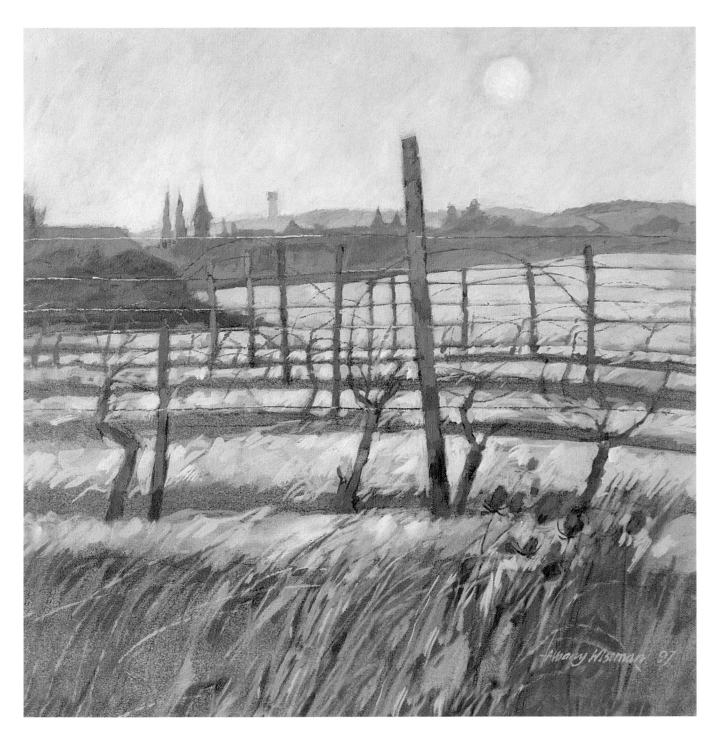

MIREPOIX, GERS
49 x 49cm (19¼ x 19¼in), oils on linen canvas

This picture was broadly based on one of the sketches, but the other was also in my mind and to hand when I worked up the painting in the studio. My support was a linen canvas sealed with three applications of an acrylic canvas sealer, which is milky when applied but dries absolutely clear. This allows the colour and texture of the canvas to contribute to the finished picture. You could also use acrylic medium; the result would be exactly the same. I modified the composition to create a more graphic image,

playing up the repetition of the rows of vines and the wires between the posts. I have cropped the sketch to make the tallest post more central and significant so that it draws the eye to the pale sun. I made a very light underpainting in acrylic, which dries quickly and gives a matt finish, and when that was dry I worked in oil, applied quite thinly. Notice the way the warm brown linen ground shows through the paint layers, contrasting with and emphasizing the chilliness of the scene.

CHAPTER 6
ARCHITECTURE

Drawing buildings can be daunting if you have not tackled the subject before, but if you have a basic knowledge of perspective and are prepared to observe, measure and draw accurately, the process is actually much the same as any other subject. I have always been interested in architecture and have drawn buildings of all sorts all my life. Over time I have developed a certain skill, so architectural drawing comes fairly easily to me. Because I have this ability I am often

commissioned to make drawings, paintings and prints of buildings, which means that I keep on drawing them; and it is undoubtedly true that the more you draw, then the better you become.

Obviously you have to draw the basic structures correctly or the building will look odd. If it is symmetrical look for the centre point. Count the windows, note their proportions and get the glazing pattern right. In a Georgian house, for example, you will usually find that

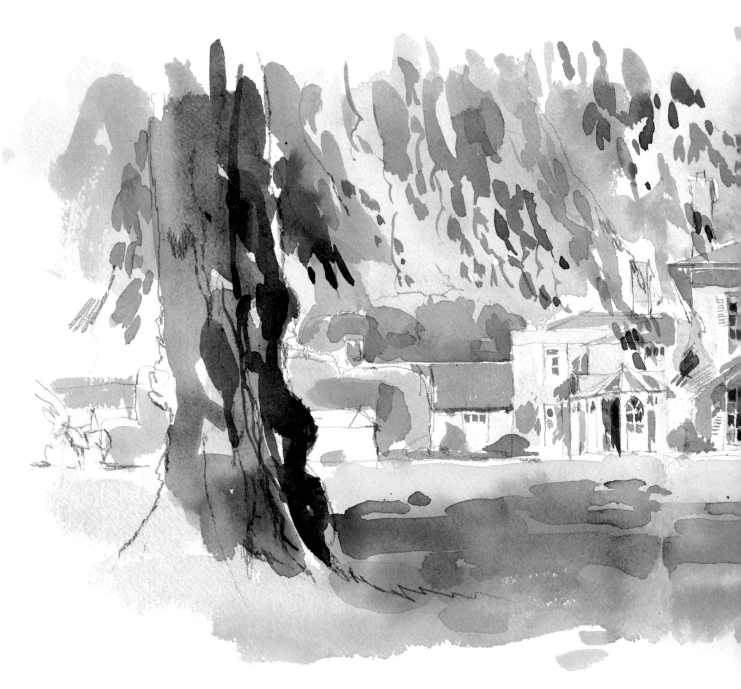

the sash windows are mathematically proportional, such as four panes in the top sash and four panes in the lower sash. By the Victorian era it was possible to manufacture larger sheets of glass, so glazing patterns changed, with one or two panes in the top sash and the same in the lower sash. As with any other subject, additional knowledge helps you to understand, and to see clearly. You do not need an in-depth knowledge of anatomy to draw the figure convincingly, but it is helpful if you have a basic understanding and awareness of the skeleton and musculature underlying the form. So with architecture: it helps if you understand the three-dimensionality of a building, and the way one part is supported on another. An interest in the history of architecture will help you to decipher what you are looking at and make more informed drawings. It can work the other way, too – sketching buildings can encourage you to find out more about why and how they were built.

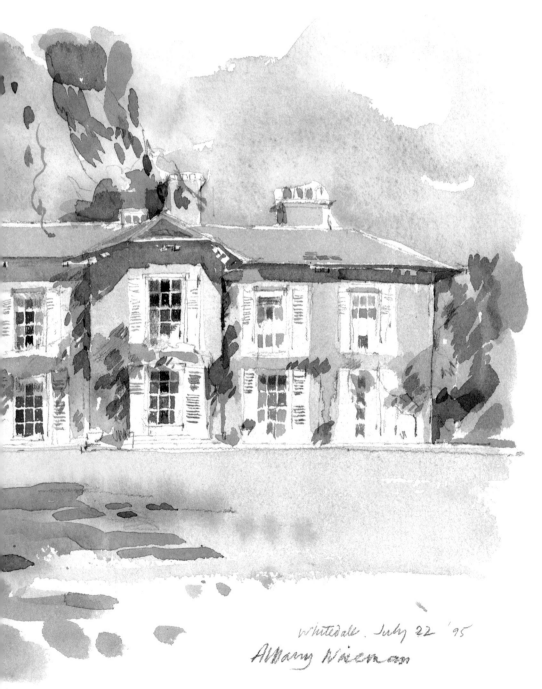

WHITEDALE

This is a fine example of the grace and elegance of Regency architecture. I only had an hour for this drawing, so I sketched in the main details in pencil and then applied washes of watercolour. My treatment of the fenestration is sketchy, but there is enough information for the drawing to read accurately. Bold marks on the tree in the foreground give a sense of scale and make the building sit back in space, giving recession from foreground to background. A frontal viewpoint like this eliminates the need to wrestle with perspective problems.

Whitedale. July 22 '95
Albany Wiseman

INDUSTRIAL ARCHITECTURE

There is a temptation to go in search of the picturesque, looking for images that are pretty and have obvious picture-making potential. But if you do, you will overlook some really fascinating subject matter. After all, we do not all live in idyllic rural settings with views of rolling fields; indeed, most people live in an urban setting. Thus it makes sense to draw and get to know the buildings and structures that surround you. Once you begin to look around you will discover the most amazing, complex, beautiful and absorbing subject matter in the most unlikely places. On these pages, for example, I have included a dry dock, a gasholder and a power station. But why not draw a petrol station, a railway station or a building site? If you are in the countryside draw non-obvious subjects such as grain silos and cattle sheds. Sketching helps you to develop an artist's eye, enabling you to see beauty and interest in the things that others overlook or consider too mundane to be worthy of serious consideration. After all, much great art has done just that – allowed us to appreciate the significance of everyday events and objects.

DIEPPE

The dry dock at Dieppe in northern France provided some fascinating material, with the ship braced against the walls of the dock, and the forest of gantries and cranes in the background. I used a combination of pencil and watercolour washes on an Arches watercolour sketchbook.

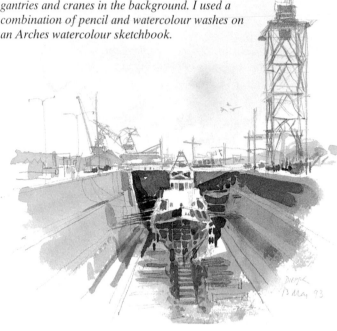

BATTERSEA POWER STATION, LONDON

This temple to power is a weird and wonderful structure, looking like an upturned kitchen table. The pterodactyl-like cranes on the left are intricate and interesting to draw, and make intriguing shapes on the page. A flurry of seabirds in the foreground gives a sense of scale, and reminds us of the natural world's ability to adapt to apparently hostile surroundings.

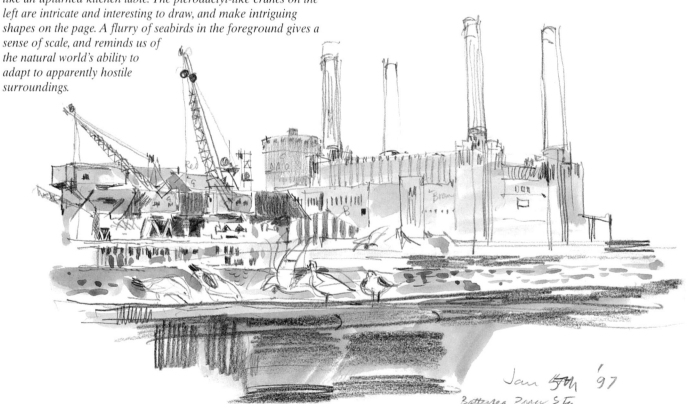

GASHOLDERS AT KING'S CROSS, LONDON

These are ingenious structures, the telescopic cylinders rising and falling to hold the varying volumes of stored gas. The columns and hoops of the external structure are surprisingly graceful. I believe the Department of the Environment has now listed gasholders as heritage structures. My eye was caught by the vibrant yellow pipework, which absolutely sings against the wintry greys and browns. I used a lot of pencil and washes of grey and brown, with tiny, but important, touches of red and yellow.

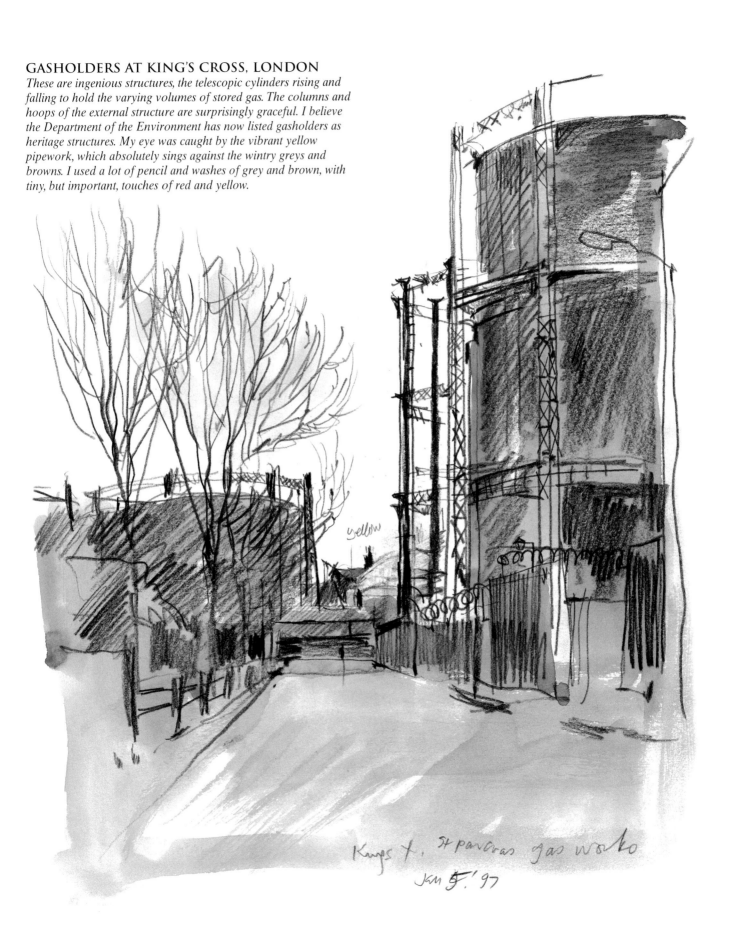

EXPLORING COMPOSITION

Artists use the word 'composition' in much the same way as musicians. It describes the process of designing, making or 'composing' a picture. It is useful because it gets away from the idea that the artist simply copies what is in front of him. In fact he organizes the elements of a picture – colour, shapes, tone, line, space, texture – within the four edges of the picture area so as to create an image that hangs together, has an internal harmony, conveys the energy and mood that he intends, is appropriate to the subject, expresses energy or stability and, above all, retains the viewer's attention.

Composition is incredibly important; it is this that really separates the work of inexperienced artists from the professionals. Yet its importance is usually underrated by amateurs. You can have the best technique in the world, but if your composition is not well thought out the picture will look weak and unconvincing.

Experienced artists compose naturally without consciously thinking about it. They edit, crop, exaggerate, play down, move and eliminate in order to create a particular effect or mood. There is no right solution. The compositional choices you make will depend on the subject and your intention. You may want to irritate the viewer, or you may want to soothe him, for example. There are no hard and fast rules, and the only test is 'does it work?'. Some people advocate that you should never place the subject right in the centre – but the central location is symmetrical, stable and attention-grabbing, so it is often used for formal portraits and religious pictures.

Your sketchbook is an ideal place to explore different formats, viewpoints and compositional arrangements. The studies on this page were all made in the Périgord region of France at St Jean de Cole. Scenes for *The Three Musketeers* were filmed on the quaint cobbled bridge.

THUMBNAILS (right)
Quick 'thumbnail' sketches like these are an ideal way of investigating the compositional possibilities of a subject. They take minutes, sometimes seconds to do, and can really help you sort out your ideas. You will notice that experienced artists almost always start to make quick doodles as soon as they see a new subject – it is an automatic response. They were completed in graphite pencil along with red coloured pencil.

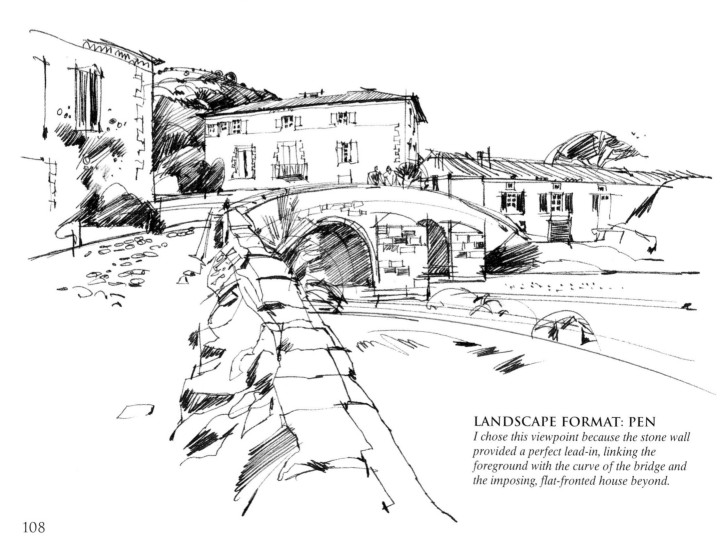

LANDSCAPE FORMAT: PEN
I chose this viewpoint because the stone wall provided a perfect lead-in, linking the foreground with the curve of the bridge and the imposing, flat-fronted house beyond.

LANDSCAPE FORMAT: WATERCOLOUR

The watercolour version is almost the same as the pen and ink, but I have dropped the image down the page so that the eye has less distance to travel into the picture. This slight adjustment and the change of medium gives this version a more intimate feel.

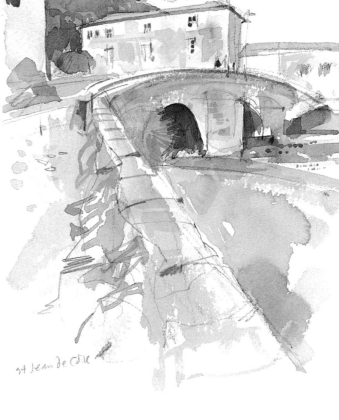

PORTRAIT FORMAT: WATERCOLOUR

The tall format is often more imposing and dramatic because the eye is forced up the picture area since there is no space for it to wander on either side. In this composition the format works well because it focuses attention on the bridge and the house, eliminating the surrounding architecture. The long diagonal of the wall has more energy than in the wider landscape versions.

FARM BUILDINGS

I am rather lucky in that many of my friends have beautiful homes in attractive parts of the countryside. These lovely old Suffolk barns extend in higgledy-piggledy fashion around a farmyard, having been added to at various times in the past. There is something particularly satisfying in buildings that have been erected to fulfil a specific function, with the design evolving from that function, and from the need to use local materials because they were cheap and convenient. Such buildings seem especially at ease in their surroundings.

The carts depicted on these pages are part of a collection, and they give a marvellous insight into the day-to-day life of country people before they embraced the combustion engine. Many of these horse-drawn vehicles would have been in use up to World War II, and possibly even into the 1950s.

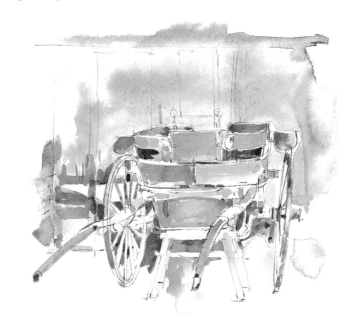

GOVERNESS OR 'TUB' CART
A light, two-wheeler cart would have been used for trips to town and for shopping expeditions. This one was found in a local barn and was in mint condition. I made the drawing in pencil, concentrating to make sure I got the unfamiliar shapes and important details right. Check things like the ellipses of the wheels, the number of spokes you can see, and the graceful curve on the shafts. I used a limited palette to obtain a range of muted browns.

TUMBLER IN FRONT OF THE BARN (below)
This study shows the tumbler cart as depicted on the facing page below, out in the farmyard. I used my Mont Blanc fountain pen to record the basic structure of cart and buildings, and to suggest the clapboard construction of the barn, the tiling on the roof and the brickwork on the pier by the barn door.

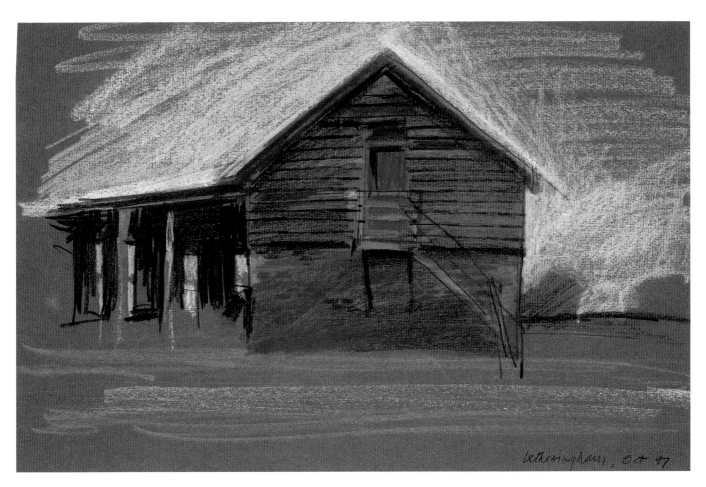

Letheringham, Oct 97

THE BARN AT LETHERINGHAM
For this drawing I used pastel on a dark Ingres paper. The colour of the paper gives a good mid tone.

SUFFOLK 'TUMBLER'
A tumbler was so called because the wagon could be tilted and the contents tipped or 'tumbled' out. It was used for drawing crops like beets and turnips from the field, and for general tasks such as transporting farmyard manure and small loads of hay and straw. It was more manoeuvrable than the big four-wheeled carts used for bringing in the harvest. I used a very free pencil line and loose watercolour washes. The colours that were used for these farm vehicles were often bright, and characteristic of a particular region.

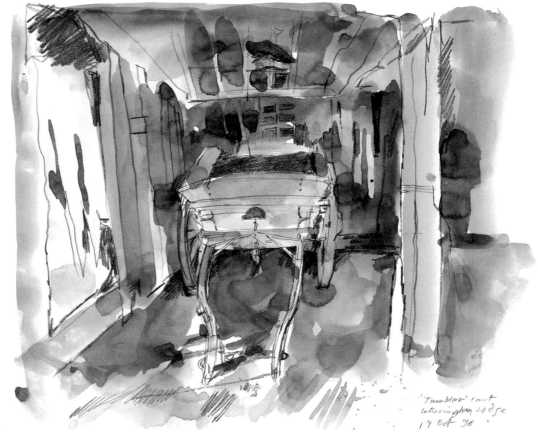

'Tumbler' cart
Letheringham Lodge
19 Oct 96

FOLLIES AND ECCENTRIC BUILDINGS

As soon as you begin to take an interest in architecture you start finding the most amazing buildings hidden away in odd nooks and corners. I do not mean grand architecture like cathedrals and great country houses, but buildings such as lodges, gatehouses and dovecotes that seem to have been embellished and ornamented out of sheer exuberance. Sometimes an apparently quirky appearance is dictated by the function of the building, as in the case of the pigeonnier in L'Isle-Jourdain in Gascony, France, but an elaborate or whimsical edifice such as the house in Le Touquet must reflect the flamboyance or eccentricity of the architect or client.

HOUSE IN LE TOUQUET

This rather flamboyant building is typical of northern French architecture. Many of these rather eccentric buildings with motifs taken from diverse architectural traditions were built at the end of the nineteenth century and the beginning of the twentieth. I sat at the top of some steps leading to a modern block of flats, which gave me quite a high viewpoint – you can see that I am above the level of the people passing in the street. I made this sketch in pencil and coloured pencil, and it probably took me about an hour. The sketch has been gridded because I later used it to produce a finished oil painting.

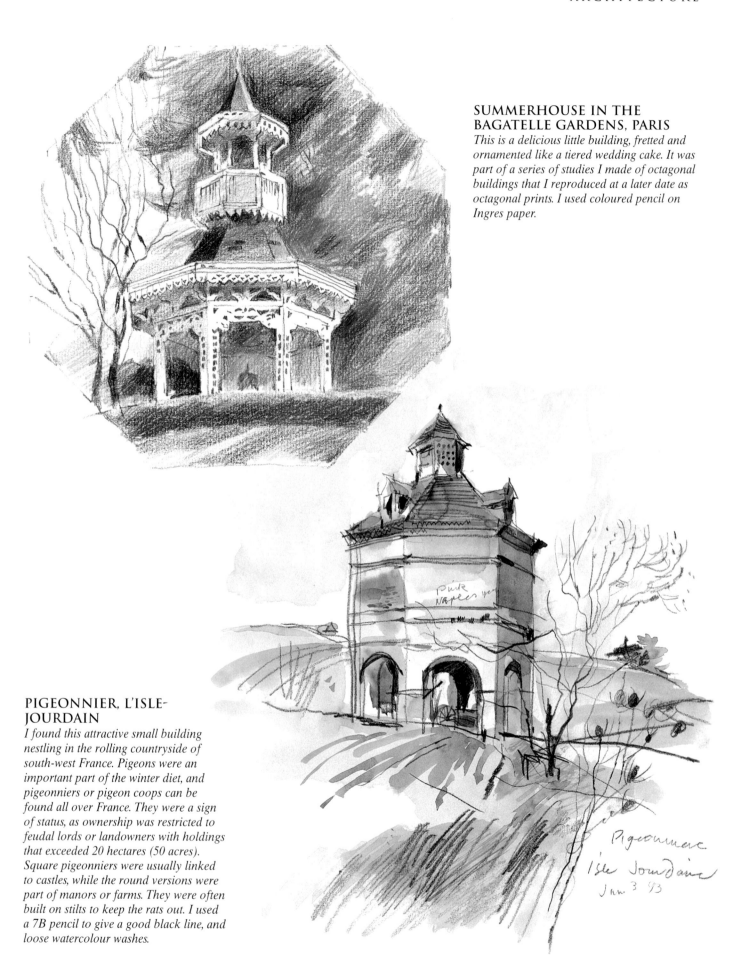

SUMMERHOUSE IN THE BAGATELLE GARDENS, PARIS
This is a delicious little building, fretted and ornamented like a tiered wedding cake. It was part of a series of studies I made of octagonal buildings that I reproduced at a later date as octagonal prints. I used coloured pencil on Ingres paper.

PIGEONNIER, L'ISLE-JOURDAIN
I found this attractive small building nestling in the rolling countryside of south-west France. Pigeons were an important part of the winter diet, and pigeonniers or pigeon coops can be found all over France. They were a sign of status, as ownership was restricted to feudal lords or landowners with holdings that exceeded 20 hectares (50 acres). Square pigeonniers were usually linked to castles, while the round versions were part of manors or farms. They were often built on stilts to keep the rats out. I used a 7B pencil to give a good black line, and loose watercolour washes.

MAGNIFICENT BUILDINGS

Buildings with a complicated ground plan, varying roof lines and lots of surface detail are lovely to look at, but can be daunting to draw. But your drawing doesn't have to be as stiff and formal as a technical drawing, with every detail precisely rendered. Although those sort of drawings are appropriate for some purposes, they can be visually unappealing. I often use a very free line for my sketches, especially when time is short. As long as the proportions and the perspective are right, and there are no jarring inconsistencies, it is amazing how one can edit and use a visual shorthand. For example, it simply is not necessary

to draw every brick and roof tile; in fact if you do, the drawing can look flat and static. If you just suggest details here and there the eye will do the rest of the work for you. So, if you find yourself admiring some fantastic piece of architecture, get out your sketchbook and draw it. Use your pencil to check the vertical and horizontal proportions, the height and slope of the roof, and the relationship of the windows and doors to the façade. Check the slope of any walls or roofs that are running away from you; once you have those elements right you can start to work very freely.

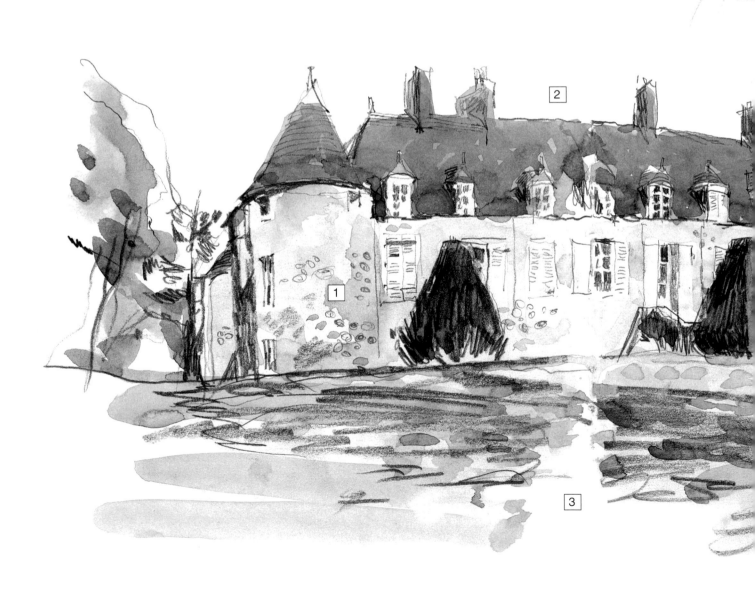

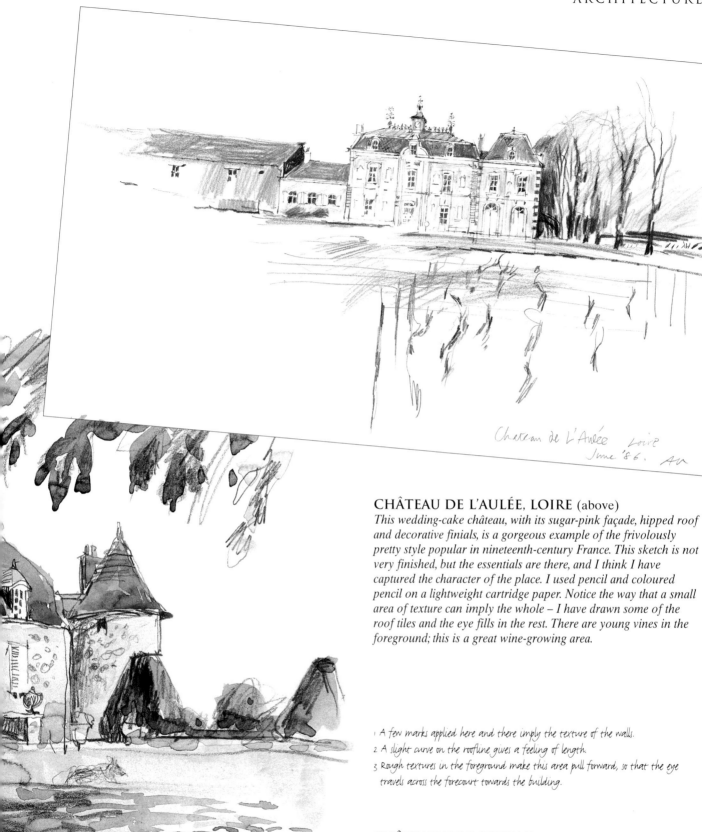

Château de L'Aulée Loire
June '86. AW

CHÂTEAU DE L'AULÉE, LOIRE (above)

This wedding-cake château, with its sugar-pink façade, hipped roof and decorative finials, is a gorgeous example of the frivolously pretty style popular in nineteenth-century France. This sketch is not very finished, but the essentials are there, and I think I have captured the character of the place. I used pencil and coloured pencil on a lightweight cartridge paper. Notice the way that a small area of texture can imply the whole – I have drawn some of the roof tiles and the eye fills in the rest. There are young vines in the foreground; this is a great wine-growing area.

1 A few marks applied here and there imply the texture of the walls.
2 A slight curve on the roofline gives a feeling of length.
3 Rough textures in the foreground make this area pull forward, so that the eye travels across the forecourt towards the building.

CHÂTEAU DE BOUSSAC

We found this splendid château in a French hotel guide book. I made this sketch very quickly without worrying too much about getting straight lines. I liked the feeling of length and the way the building with its corner towers sat so securely on the rising ground. The ever-so-slight curve on the roofline helps to give a feeling of length. I worked very quickly on acid-free paper with pencil and watercolour.

DETAILED ARCHITECTURAL STUDIES

At times a really accurate architectural drawing is required. I sometimes do limited edition prints for institutions, for example, and while a pleasing image is important, it is also necessary that all the key elements are present and in their right place. When people know and love a building they notice these points. Such a commission usually involves making several drawings. I make thumbnail sketches to work out which are the best angles, and then make a drawing from the best viewpoint. I also make sketches of important details such as the capitals on a column or pilaster, a repeated window design, or the structure of an arch. Often when I am doing a particularly demanding drawing I have to revisit the site several times to check details. Photographs are a very useful reference, so if you have a camera remember to take close-ups of details as well as overall shots.

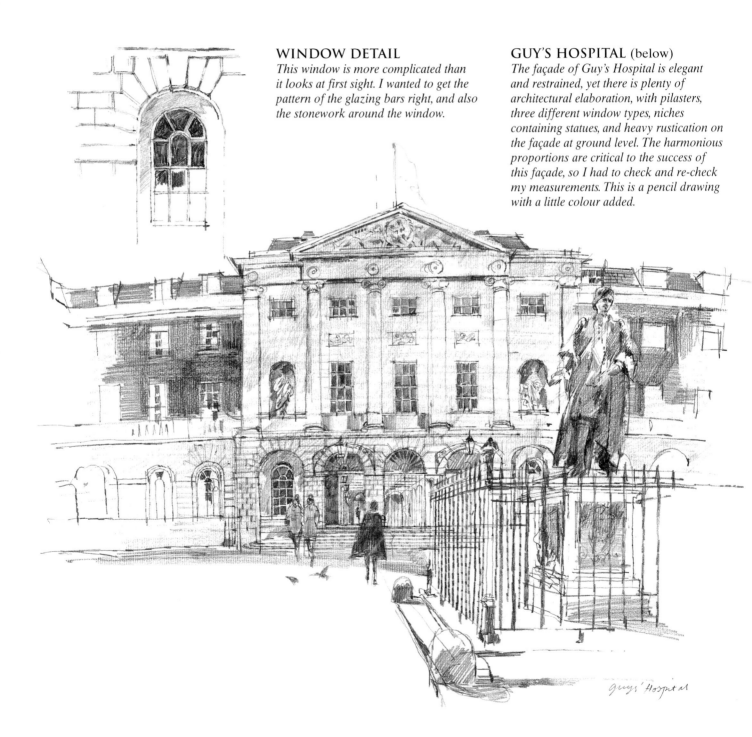

WINDOW DETAIL
This window is more complicated than it looks at first sight. I wanted to get the pattern of the glazing bars right, and also the stonework around the window.

GUY'S HOSPITAL (below)
The façade of Guy's Hospital is elegant and restrained, yet there is plenty of architectural elaboration, with pilasters, three different window types, niches containing statues, and heavy rustication on the façade at ground level. The harmonious proportions are critical to the success of this façade, so I had to check and re-check my measurements. This is a pencil drawing with a little colour added.

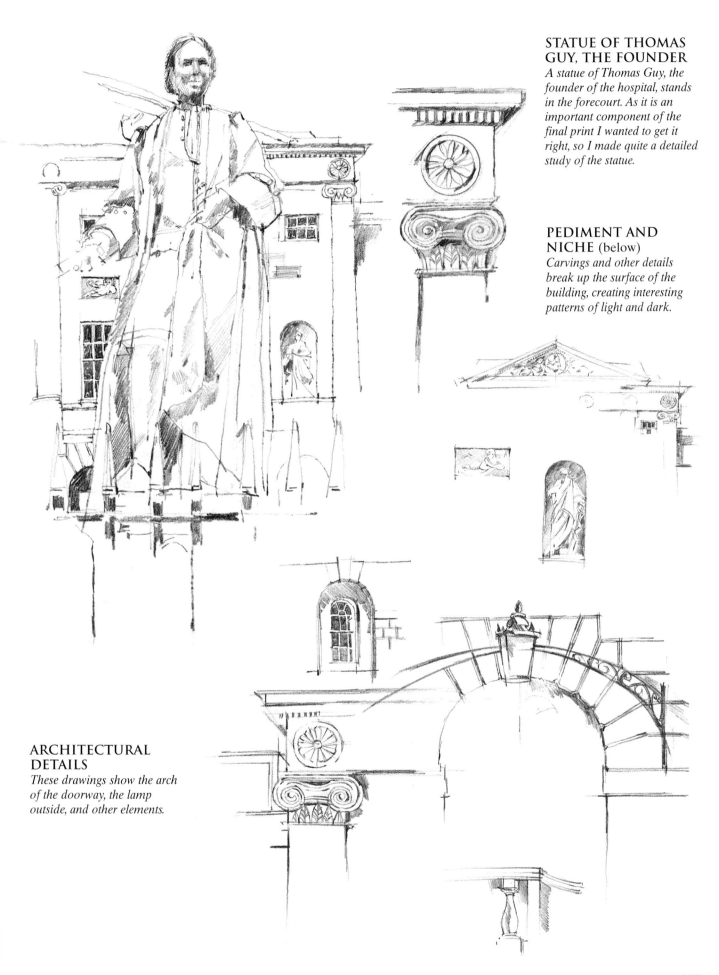

STATUE OF THOMAS GUY, THE FOUNDER
A statue of Thomas Guy, the founder of the hospital, stands in the forecourt. As it is an important component of the final print I wanted to get it right, so I made quite a detailed study of the statue.

PEDIMENT AND NICHE (below)
Carvings and other details break up the surface of the building, creating interesting patterns of light and dark.

ARCHITECTURAL DETAILS
These drawings show the arch of the doorway, the lamp outside, and other elements.

117

LETTERING

I love lettering. It is so varied and so characterful, and often so overlooked, although it is an intrinsic feature of everyday buildings and the world around us. I especially like the work of the old-fashioned sign-writers who went about on their bicycles with their brushes and paints and produced signs to order. They were marvellous craftsmen and their work had a particular quality that has been lost in today's mechanically produced lettering. Lettering can bring a splash of colour to a scene, and comes in an infinite range of styles and sizes.

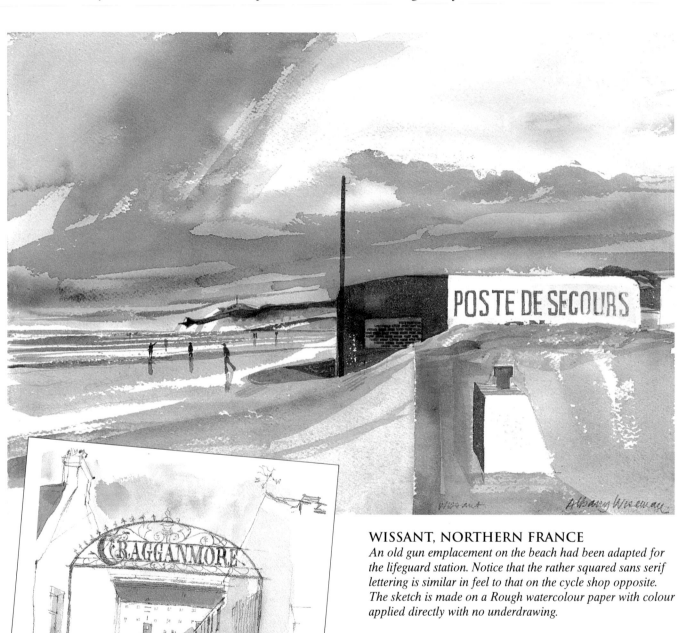

WISSANT, NORTHERN FRANCE
An old gun emplacement on the beach had been adapted for the lifeguard station. Notice that the rather squared sans serif lettering is similar in feel to that on the cycle shop opposite. The sketch is made on a Rough watercolour paper with colour applied directly with no underdrawing.

DISTILLERY, SCOTLAND
I have included this sketch for the wonderfully ornate lettering in cast iron. In contrast with the lettering above, each character is comprised of thick and thin lines. These slab-serif typefaces are called 'Egyptian'. The sketch was done in pencil and I then applied some simple washes.

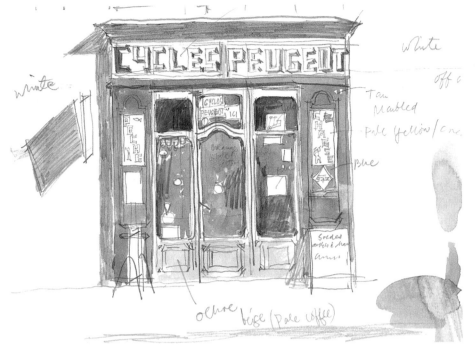

CYCLE SHOP

This cycle shop could not be anywhere but France, could it? The square sans serif face with its three-dimensional shadow effect is typical of its time and place. I like the contrast between the old-fashioned shop front and the consciously modern letterforms. I worked in pencil and watercolour, and you will notice that I have annotated the sketch extensively with notes about colour.

SHOP FRONTS

These sketches were made for a lithographic print of shop fronts. All these shops were in Charlotte Place in London's Fitzrovia, and all were within a hundred metres of each other. These shop fronts had a great charm – and all of them, including the barber and the fish merchant, have long gone.

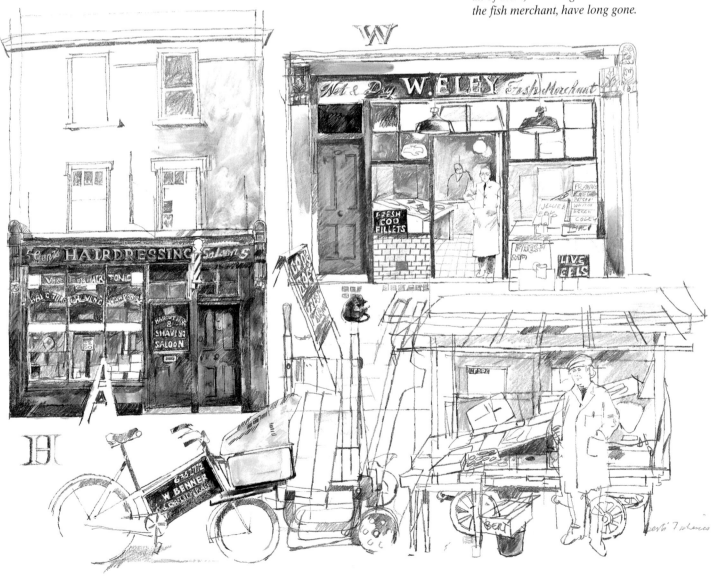

BRIDGES

The springing shapes and rhythmic lines of bridges provide splendid material for the artist. Bridges are fascinating and varied structures, ranging from the solid brick stone arches produced by the Romans to the unbelievably light suspension structures designed by visionary Victorian engineers. This is yet another area where the more you look, the more you will see.

Bridges are often structurally complex with many functional and decorative details that can be confusing. As with any new subject, you should start by simplifying the forms, looking for the significant lines and shapes, and for the distribution of light and dark. Try and comprehend the three-dimensional form that underlies the structure. It is easy to be distracted by the surface decoration, but leave that until you feel you have a solid weightbearing structure. Perhaps you should start with a very simple sketch of the 'skeleton' to fix the underlying forms in your mind.

Another fascination of bridges lies in their impact on the landscape. Some seem to settle into it, their lines reflecting the landforms around them, while others provide a graphic focal point, in sharp contrast to their surroundings. By choosing your viewpoint you can use a bridge to draw the eye into a picture, or to frame an element of it.

BRIDGES ACROSS THE TYNE, NEWCASTLE
Apparently there are five bridges across the Tyne, and here you can see three of them through the arc of the main one. I was there to draw the offices of a shipping company on the dockside and these were sketches to show alternative viewpoints. I used pencil, taking the drawing across the double spread. I then applied quite limited areas of watercolour wash. It is a very free drawing, but it seems to capture the character of the place.

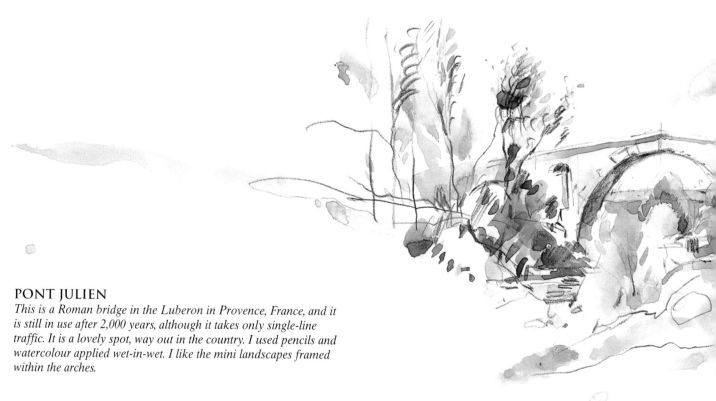

PONT JULIEN
This is a Roman bridge in the Luberon in Provence, France, and it is still in use after 2,000 years, although it takes only single-line traffic. It is a lovely spot, way out in the country. I used pencils and watercolour applied wet-in-wet. I like the mini landscapes framed within the arches.

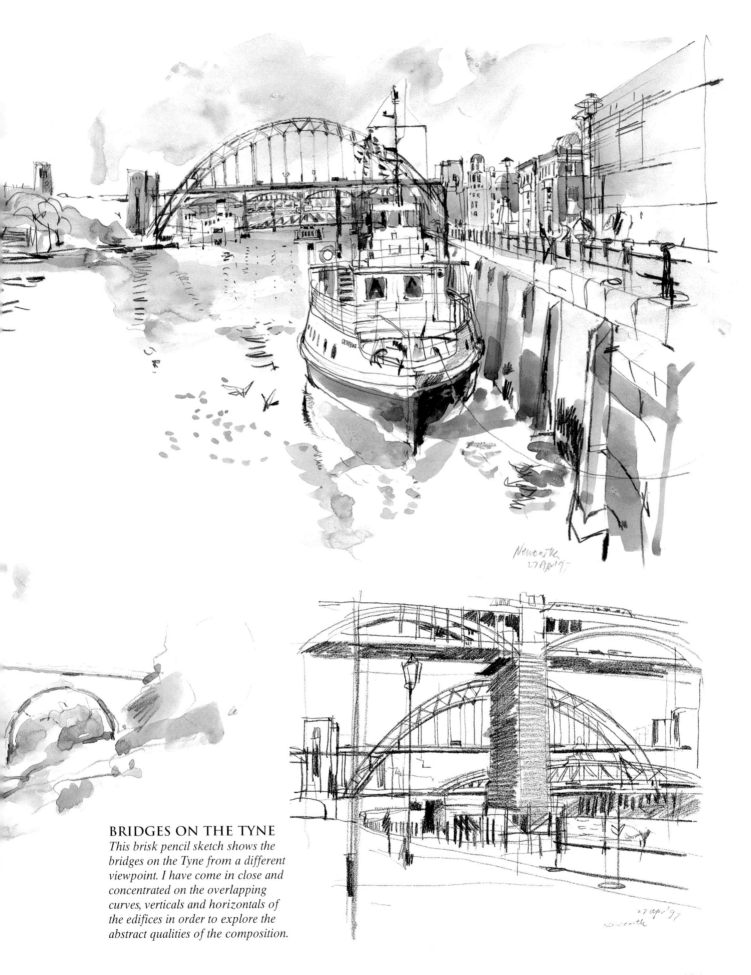

BRIDGES ON THE TYNE
This brisk pencil sketch shows the bridges on the Tyne from a different viewpoint. I have come in close and concentrated on the overlapping curves, verticals and horizontals of the edifices in order to explore the abstract qualities of the composition.

THE CHARACTER OF A PLACE

All the sketches on this page were preparations for a commission – a multiple-image print of Aberdeen University. The brief was to produce an image that captured the character and beauty of the place, and I was given a list of likely spots. I made about ten sketches, some in pencil and some in watercolour and pencil. I have done many drawings of architectural subjects and practice has given me an understanding of the forms. Many people find the complexity of buildings difficult but sketching buildings is really no different from anything else – you look, you measure, you make marks and you adjust until it is right. Photographs are useful as visual reference because they contain more detail than you could hope to get down in a relatively quick sketch, but they are no substitute for the drawing. You know a subject in a very special way when you have drawn it and, of course, the eye sees in a very different way from the camera, and you can make adjustments to create a better composition.

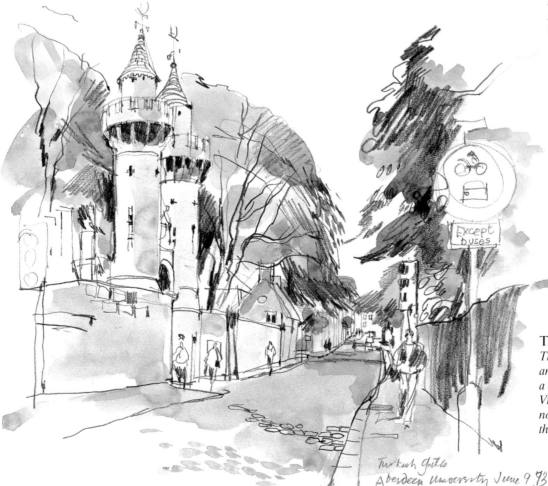

THE GROUNDS
With the expanses of grass, the graceful tree in the foreground and the students basking in the sunshine, this view had a lovely lyrical quality.

TURKISH GATES
These minarets are an amusing device to find in a Scottish backstreet. The Victorians were certainly nothing if not eclectic in their architecture.

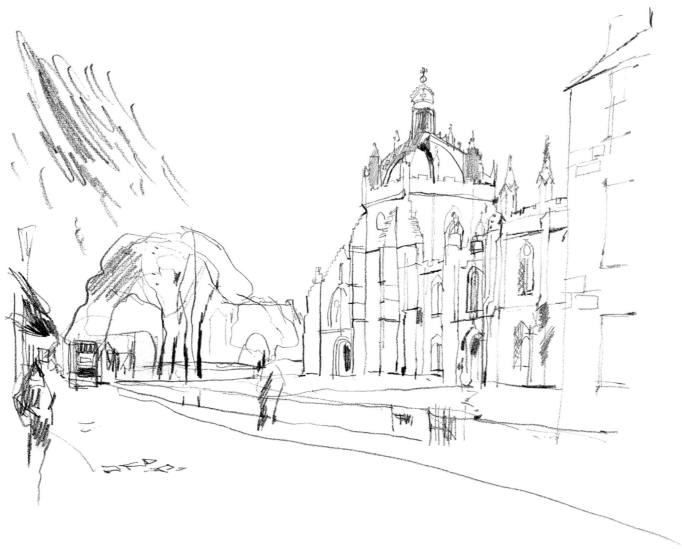

MAIN ENTRANCE
This viewpoint captures the solidity and the grandeur of the building.

THE PRINT
The finished print was based on a montage of various scenes that I had sketched. I used my original sketches and referred to photographs when I was uncertain about what exactly was going on, or if I wanted details. I hope that prints like this help people to look at scenes that have become familiar to them and see them afresh.

FURTHER CHALLENGES

Much of the success of drawing buildings relies on skill in drawing complex shapes in perspective. There are many subjects that can help to develop your observation and the accuracy of your drawing. Vehicles of any sort are fascinating subjects to sketch, and some set real technical challenges. Boats, in particular, are essentially pleasing shapes, but endlessly varied in detail. Models and toys can be a useful way of investigating complex structures, and because they are relatively small it is easy to turn them, or to move round them, so that you can study them in detail.

I have several models of ships, beautifully made with all the rigging intact and accurate. I draw them from time to time, because they are so beautiful, but also because they really test my powers of observation and my ability to draw accurately. The English artist J. M. W. Turner (1775–1851) frequently used models of ships for his marine studies. Bicycles are another subject that I practise on now and then; they are complicated and difficult to draw because of the effect of perspective on the circle of the wheel.

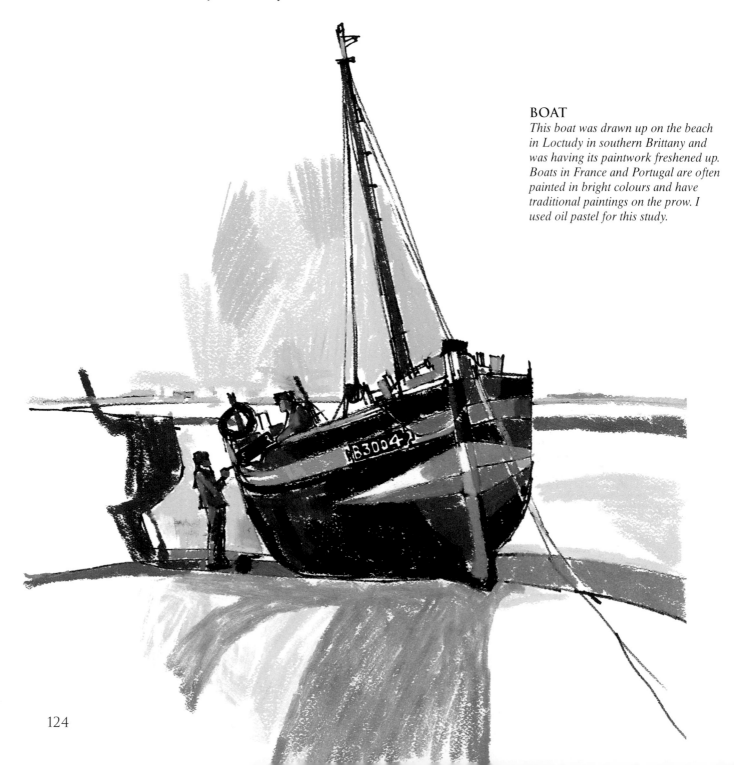

BOAT
This boat was drawn up on the beach in Loctudy in southern Brittany and was having its paintwork freshened up. Boats in France and Portugal are often painted in bright colours and have traditional paintings on the prow. I used oil pastel for this study.

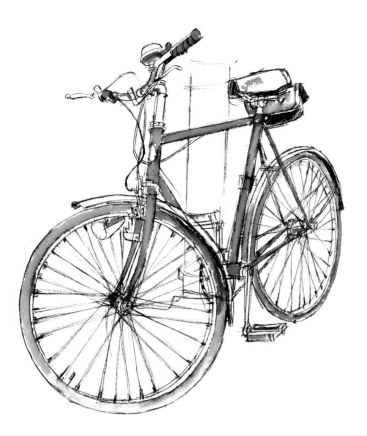

BICYCLE
I did this drawing directly in fountain pen, which meant that I had to get it right first time. I counted the spokes and studied their pattern carefully, so they should be right. I completed the image by going over it with a brush wetted with water, to give a general tone.

SCHOONER
This is a professionally built model of a boat called the Caradoc *and the standard of craftsmanship and detail is very high. The model now resides in a glass case in my living room. It was quite a painstaking subject to draw, and I used pen to give a crisp line.*

VOTIVE MODEL
This particular ship is a French votive model dating from the early nineteenth century. It is crudely made, but would have been carried in procession through the streets on saints' days as an offering to ensure the safe return of the town's sailors. Models were often hung around side altars in churches as votive offerings.

TOYS
The Hansom cab is a scale model that I bought from a professional modelmaker, and the London taxi is a Corgi toy. I made the sketches in 7B pencil on cartridge paper.

FROM SKETCH TO FINISHED PAINTING: ST SAVIOUR'S DOCK

This is St Saviour's Dock, near Oliver's Wharf on the south bank of the Thames. Apparently this area was the setting for Dickens' *Oliver Twist*. I sketched around here some time in the 1970s and 1980s before the extensive renewal of the old docks was under way, but only recently produced a painting from those sketches. The area has been tidied up and gentrified, but the buildings, street layouts and waterways remain much the same. From an artist's point of view, however, it was much more appealing when it was slightly derelict and dilapidated. With so much redevelopment of this part of London, my sketches in pencil and watercolour now form an historical record as well as a source of inspiration.

ST SAVIOUR'S DOCK
34 x 24cm (13½ x 8½ in), oils on panel
The support is a piece of wood, which is a traditional support for oil paintings. I had a spare piece lying round and thought I might as well make use of it. I sealed it with PVA glue, which dries to a transparent finish, so as not to obliterate the rich red colour of the wood. I then transferred the sketch to the panel. I liked the canyon-like dock with the massive, cliff-like buildings on either side. I also liked the way the pale blue 'V' of the sky seemed to be funnelled down into the water of the dock. At the end of the dock, and almost plumb in the middle of the painting, the view across the river is framed, creating a picture within a picture that draws the viewer's eye inexorably into the centre of the composition. The sudden change of scale suggests distance, but also gives this area the jewel-like quality of a miniature. I used a rather muted palette that plays off warm putty greys against the cool dove greys and blues of the sky and water. The red of the support shows through the paint surface, giving the picture a lively quality.

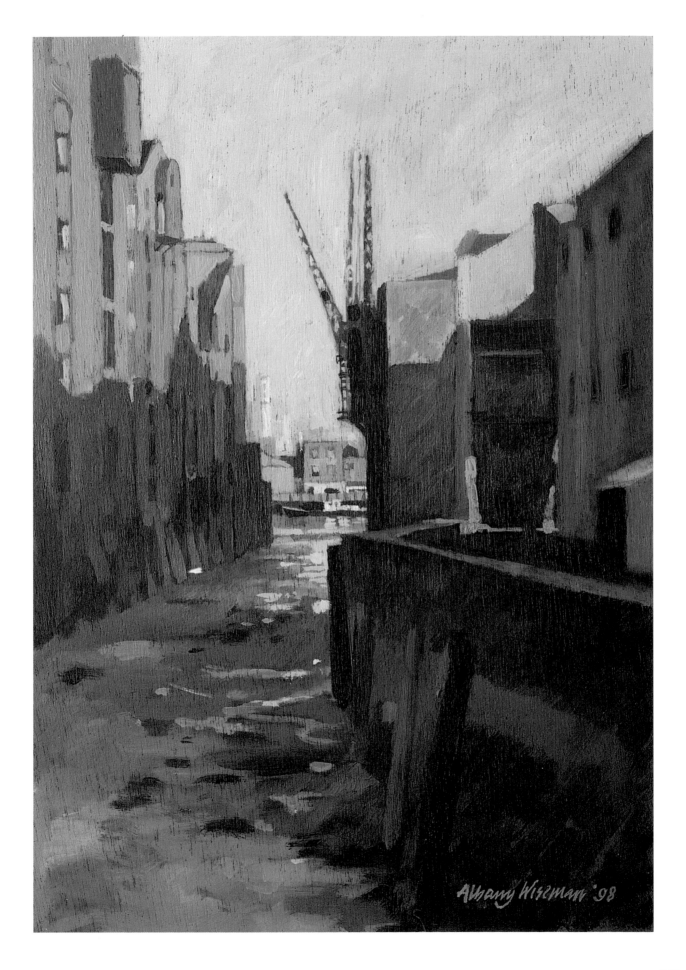

INDEX